How to Research the Internet for Fashion

M. Kathleen Colussy

PEARSON

Prentice
Hall

Upper Saddle River, New Jersey 07458

Library of Congress Cataloging-in-Publication Data

Colussy, M. Kathleen.
 How to research the Internet for fashion / M. Kathleen Colussy.
 p. cm.
 ISBN 0-13-172762-1 (paperback)
 1. Fashion—Computer network resources. 2. Fashion design—
Materials—Computer network resources. 3. Internet—Directories.
I. Title.
 TT507.C66 2005
 025.06'74692—dc22

 2005054970

Director of Development: Vernon R. Anthony Managing Editor: Mary Carnis
Senior Editor: Eileen McClay Production Liaison: Janice Stangel
Editorial Assistant: Yvette Schlarman Manufacturing Manager: Ilene Sanford
Production Management: GGS Book Services, Manufacturing Buyer: Cathleen Petersen
 Atlantic Highlands Cover and Interior Design: Paul Kane
Production Editor: Trish Finley Printer/Binder: Courier Companies, Inc.
Director of Manufacturing and Production:
 Bruce Johnson

Pearson Education LTD
Pearson Education Singapore, Pte. Ltd
Pearson Education, Canada, Ltd
Pearson Education–Japan
Pearson Education Australia PTY, Limited
Pearson Education North Asia Ltd
Pearson Educación de Mexico, S.A. de C.V.
Pearson Education Malaysia, Pte. Ltd

10 9 8 7 6 5 4 3 2 1
ISBN 0-13-172762-1

Contents

Preface
Going beyond Google!

Sourcing Online . . . Who Needs It?

The design students and industry professionals of the twenty-first century have the needed knowledge and skill sets to successfully mine the Internet for information that is no longer an option or a luxury—it is a necessity. While the market has several books geared to research methods in general, to date no one has addressed the issue for the design professional, including those of the fashion, graphic, or other creative fields.

Unfortunately, even in today's high-tech society a percentage of the creative world is still unskilled or untrained in the techniques that are necessary to master the Internet for serious research. A significant number of those in the creative world still assume that the Internet is basically a medium for communicating emails and perhaps for consumer online shopping and not much more. Learning to successfully navigate the Internet for information can be daunting.
The extent of research savvy that a student or industry professional requires varies greatly, from the novice to the proficient and everything in between. Therefore, it was only logical to begin putting together this book and CD in a structure that would help the widest assortment of readers.

Goals for the Text and CD

I saw my role of author more as that of a hunter-gatherer. There seem to be many great business and fashion websites out there that nobody knows about. So I set out to help my students mine the Web for the hidden gems I had come to discover over the years.

As I began this quest I realized there was also a lack of basic how-to-research knowledge for many of today's students. On the plus side, over the years I have observed an increase in basic computer skills. Therefore, an assumption was made that the reader already possesses the basics of computer literacy skills, which include logging-on to the Internet, obtaining and accessing an email account, as well as being competent using a word processor and managing files, before beginning this text.

What you can expect to find in the succeeding chapters are the basics of how to conduct traditional and nontraditional research. In the exercise portion of the

text you will find that it has been designed to help improve the learning curve for the reader to conduct the majority of his or her research online.

One clear objective for this book and CD is to help the reader overcome any Internet research phobia. The book was written to help dispel fears of inadequacy, which really stem from ignorance or lack of knowledge on how to use the Internet for research. My goal is to make you proficient and confident in using the Internet and the computer as a tool for conducting research. Wouldn't it be nice to no longer have to pretend that you understand what the experts are talking about and have the savvy skills needed to find the answers you are looking for?

Wouldn't it be satisfying to save valuable time and money to obtain the answers and solutions you need? In this CD, we will begin by helping you tackle traditional research sources and methods used in the industry, then move on to locate these sources online.

You'll learn to:
- Demystify the Web as a tool for research and sourcing
- Recognize and comprehend the differences as well as the commonalities between traditional and nontraditional research methods
- Simplify popular research methods for conducting a successful query online
- Overcome language syntax
- Garner the skills necessary to successfully conduct fashion, business, and marketing research online used by industry pros
- Uncover the secrets of mining the Deep Web or hidden Web for answers and solutions

As you move forward into advanced researching skills you will soon discover yourself "power searching" in no time. Regardless of your sourcing savvy I highly recommend that you take time to review all the materials included before launching the CD and attempting the exercises. Give yourself the luxury of reading through the text and making notes as you follow along; it will enhance your learning and comprehension.

For the most part in the CD, you will find important URLs that will link you to a wealth of savvy industry-relevant sites. Portions are included that are

targeted for the advanced power user who needs to access current and accurate information fast! Like any other industry, the best-kept secrets of the Internet are for those who know how to successfully master the Deep Web searching methods often known by only a privileged few. In no time you will be mastering the superhighway as an invaluable resource for your sourcing needs.

Finally, the focus of the book's instructional information has been geared to the industry professional specifically for fashion. While the text is not limited to the fashion student or fashion professional, you will soon discover that much of this text is not about fashion—but rather about how to successfully research.

Fashion touches *everyone's* life, which is why it was the vehicle chosen to empower you to garner the skills necessary to be competent at traditional and nontraditional research. I trust this book will help you on your journey and that you will pass along the information to anyone struggling with how to mine the Internet!

Acknowledgments

First and foremost, to Paul Kane, my production manager—you are by far the most patient mensch I know. Your kindness and talent to help turn this vision into a reality is much appreciated. To Jo Peswani for coming through with technical edits in the eleventh hour. To my favorite librarian, Brian Frasina, and my former student Belinda Pizzarro *who spent hours and hours* verifying every single one of the links—God bless you both!

To Vern Anthony for helping me send this book to press "outside the typical process." Hurrah! Thank you to Eileen McClay—hopefully many more to come; to Trish Finley, Janice Stangel, and Michelle Churma for fielding all my questions and concerns with grace; to Meredith Chandler, who signed me; to my students, past, present, and future—I trust you will see in every book I write that my heart is always to bless and empower you!

Thank you to all those companies and individuals, named and anonymous, who have assisted along the way. I appreciate your support.

AIFL Learning Resource Center—Stephanie, Diane, and Heather
About.com—especially Cynthia Neils

AltaVista—Deb McCleod (Yahoo! Marketing Manager)
Amazon
AOL (America Online)
Ask Jeeves
Barnes and Noble—Christine and Ranette
Cotton Inc.—Clair Depuris and Kim Kettings
FashionDex.com
FashionSnoops—Itay
Brian Frasina
Google
Graphics of the Americas—Chris and Anne
Hoover's
Jesus, what a great boss! Can you believe it has been almost 24 years?
Paul Kane—I just had to say thanks one more time!
Belinda Pizzaro
Pointcarre—Gabby Shiner and Steve Greenberg, you two are the best!
Sagebrush Corp.—Mike Wilkes, Mary Campenot, and Jeanne Woods
SnapFashun—Wendy Bodini
[TC]2—Kim Davis
Garry Tepper, artist extraordinaire!
TechExchange.com—especially Jud Early
TravelPro™—Marcy and Kim

Kathleen Colussy

Every effort has been made to ensure the timeliness and accuracy for each of the URLs listed in the text and on the CD. It is important to realize that the Internet is very organic and dynamic; a viable website can be here today and literally gone tomorrow. Many times, websites disappear for a variety of reasons such as mergers, acquisitions, revamps and site overhauls, and even lack of funds or traffic.

The results in this book are as unbiased as humanly possible, and no company or agency influenced the making of this book and CD. The book and CD were a result of my sincere efforts as a career educator to help empower the next gen eration of fashion professionals to make the most of their online experience.

All of the websites have been tested by independent testers along with BETA testing in the classroom; therefore, if any errors have been discovered I encourage you to contact me at my website: http://www.ComputersandFashion.com, to report any new findings or suggest corrections.

I believe this book will continue to be an invaluable resource for the creative professional, thus I encourage you to send your comments or suggestions.

Long hours of time have gone into providing you with the most complete bank of research and resourcing URLs available today. Naturally, all the material is copyrighted and you must have written permission to make any copies from the book or CD. I regret that the fashion industry as a whole does somehow inadvertently teach us that it is OK to steal, when in truth it is not OK. It is evident in the vocabulary we use: swipes, rub-offs, and knock-offs, <grin>. However, as we have learned over the years, duplicating CDs is illegal and an infringement on the owners' rights. Therefore, I sincerely request that you do not make copies of the book or the CD to distribute them to your peers but instead kindly encourage them to obtain the text for their own libraries. This act of kindness and honesty is greatly appreciated!

One last thing as you visit any of these sites—I encourage you to let them know you discovered them in this text.

Sincerely,

Kathleen Colussy

About the Author

Kathleen Colussy

Kathleen is a 20+ year educator, author, and artist at the Art Institute of Fort Lauderdale in the Fashion Department and has been awarded numerous Who's Who in Teaching awards. She has also been the recipient of the Teacher of the Year in the State of Florida in 2000–2001 and again in 2004–2005.

Kathleen hosts several websites, including http://www.ComputersandFashion.com for her students and http://www.MKathleenColussy.com that showcases her art.

Kathleen has authored several other textbooks for Prentice Hall including:
- *Fashion Design On Computers* (2000)
- *Rendering Fashion, Fabric and Prints with Adobe Photoshop* (2004) with coauthor Steve Greenberg, with a follow-up book *Rendering Fashion, Fabric and Prints with Adobe Illustrator* (projected availability Fall 2005)

In 2006, Prentice Hall will publish a fashion history text by Kathleen entitled *Fashion Undressed.*

Beyond her achievements, Kathleen says her biggest accomplishment has been being a wife of 32 years, a mom, and a grandmother.

Dedication: For my two dads in heaven and to LH, my love and thanks!

1. Sourcing: What Is It . . . and Who Needs It?

Terms to look for:
Economic resources
Independent
Inspirational resources
Major designer
Manufacturer
Marketing materials
National brand
Press kits
Private label
Sourcing

This chapter will address the following questions:
• What is sourcing?
• Why is sourcing important to the professional?
• Who does sourcing?
• What will I be expected to source?
• Where do I begin?
 Questions . . . questions . . . questions.

It seems everything starts with asking questions. This book and CD are about questions—asking questions, getting answers. Isn't that what research and sourcing is all about? You will soon discover that part of getting answers is being sure that you are asking the right questions, including asking the question in the right way, and asking the right source to obtain the right solutions or information to meet the needs of your company and clients.

These next few sections are designed to answer questions, as well as eliminate those fears and misconceptions about where and how to begin your research. Instead you will soon discover the tools to simplify your understanding of how to research as well as glean proven research methods that are systematic and simple to replicate. Best of all, the CD even comes with a complete alphabetical listing of all the favorite secret sites that tend to go under the radar when doing a basic search engine query.

Areas we will be covering are:
• What is sourcing, who sources, and how you can source successfully
• Traditional research sources such as libraries and trade shows
• Nontraditional online sources

What Is Sourcing?

Let's define what sourcing is to the fashion industry. Sourcing is fashion-speak for asking questions and looking for answers to questions or solutions to problems. (OK, I mean challenges!) Just imagine you need a new resource for muslin fabric because your old supplier or mill has gone out of business, and believe me that can be a real challenge. This book is about where and how to begin to search for answers to questions and solutions for challenges. Officially, sourcing is finding the right information, people, and products or services at the right time, from the right source, and at the right price.

Perhaps you are a fashion retailer searching for trend information, or maybe you are a fashion designer looking for a new supplier. Whatever role you find yourself taking in the fashion industry, somehow part of your job will involve research. It is unavoidable!

For example, product developers and designers are frequently faced with myriad choices when developing a line, all of which involve practical information that begins first and foremost with the consumer.

Oftentimes as designers are creating lines they find the need to make adjustments to a design. The reasons can vary, but ultimately changes are always made to ensure the definitive goal is to produce a product that a consumer will buy. That means the designer needs to know:
• How much the consumer is <u>able</u> to spend
• How much the consumer is <u>willing</u> to spend
• What are the key fashion trends, including, but not limited to fabrics, colors, silhouettes, and trims
• How all of this can be produced at a competitive price

So, to summarize, sourcing is finding the right information, materials, colors, and manufacturing centers, and learning about consumer habits, preferences, and much more. Sourcing has always been part of a designer's job.

How Is Sourcing Done?
Let's dig a little deeper to understand this concept.
You will often hear the term *sourcing* in the fashion industry in relation to finding the raw materials and manufacturing facilities to develop lines, and to promote effectively techniques that are in line with the consumer market being targeted. If you spend any time at all talking with *designers* you will find their focus—the visions and resulting designs—is strictly on the materials and findings. They are always looking for unique fibers, textures, colors, and trims. If you talk

to *production/business managers,* you will constantly hear them talking about finding the most productive manufacturing facilities and the best way to target the consumer. If you talk to *sales and marketing department staff,* their focus is on the most effective tools to sell to both the wholesale and retail customers.

Let's concentrate on this topic of marketing as it applies to sourcing and explain why it is so important at this stage of the game for a designer to better understand.

The principles of marketing generally focus on the four Ps: . . . **price, place, product,** and **promotion.** But true marketers will tell you that the real emphasis is not on the four Ps, but rather on the ability to create exchange (dollars for product) in order to gain customer satisfaction. This means not only that the customers bought the goods or services, but that they are satisfied and will continue to return for future purchases. If a designer can consistently satisfy consumers and give them new product lines each time they return to purchase, the result will be an increase in business. In the past, even though designers and manufacturers provided the consumer with satisfaction, they failed to offer the consumer something new or different. Therefore when the consumer came back to shop, the consumer was disappointed, which may have resulted in lost revenue or, worse yet, lack of consumer confidence or loyalty.

With all the new technology of the twenty-first century, designers are empowered to produce twice as fast as before. The consumer does not have to leave a store emptyhanded or throw away a catalog because there is always something new. Competition has become fierce, and, thanks to the computer and the Internet, this has become a major contributing factor. So, let's take a closer look at the role the computer and the Internet play in successfully sourcing.

Do all companies source?
Yes!
Quite frankly, it does not matter where your expertise lies because your creative skills and abilities will land you in one of the following places:

- You may be working as an <u>independent</u>. That means your own name is on the label, just like Tommy Hilfiger or Donna Karan. Although being an independent designer may be your dream, getting some on-the-job experience is very important when you are starting out. It's likely that you'll begin your fashion career through various intern positions.

- You may work for a major manufacturer, like Levi Strauss or Vanity Fair's VF Corporation. Here you will work with a number of design team members creating a series of product lines that are representative of the company image.

• Design opportunities may surface with the leading retail teams, developing and <u>designing national brands</u> such as INC® (International Concepts) for Macy's or The Arizona Jean Company® for JCPenney.

• You may ultimately work to develop products for well-known private label companies like Gap or Victoria's Secret.

It doesn't matter where you hang your design hat. What is important is to emphasize that the business/operations team is going to be consumed with finding materials that are competitively priced so the design firm can offer the customer the best-valued product at the most competitive price. It is widely known in the design world that fabrics generally are the most costly factor in the total price of a garment.

Who will be doing the sourcing?
You will!
No matter where you work in the design cycle, expect to be a contributor. Everyone in the fashion industry today will tell you that at some time in doing their job they need to search for information; it may be details on fabrics and trims, it may be quotes for manufacturing, or it could be on consumer research. What matters most is that you know how to source and, even more importantly, find the information as quickly as you can.

Even though a designer would love to just create, the most successful designers realize the role merchandising plays in their success. That means from a sales and marketing viewpoint, they have to know about the healthiness of the economy and the lifestyles and buying power of their consumers. From a production viewpoint, they need to find the right textile mills to work with, the key trade shows to attend to search for well-priced findings, as well as determining the right manufacturers to produce the line. A successful designer knows finding the right sources has to go hand in hand with the keen eye of design.

Is sourcing used only after the designer has created a line?
No!
Sourcing is a technique that is applied in all facets and stages of design.

Let's review just a sampling of fashion-related companies that source:
• Fiber producers
• Fabric producers

- Designers
 - This includes independent designer labels such as Tommy Hilfiger
 - National brands such as JCPenney or Sears
 - Private labels such as Victoria's Secret
 - Major manufacturers such as Vanity Fair or Levi Strauss

Most designers don't try to handle sourcing alone. They look for help from many departments including sales/marketing, technology, production, and their own design team members. With the challenges to compete in today's global market-place, computer technology has made sourcing quicker, sharper, and accessible to all. With the help of production managers, findings buyers, and fabric buyers, designers must don their business hat, roll up their sleeves, and work quickly with their design team to gather the information they need. Timing is key here; Since the information is available to everyone, sharp decisions have to be made quickly to maintain the competitive edge. The bottom line is that <u>every member</u> of the design team will need a computer to quickly gather the data that will aid the decision-making process.

You'll soon realize the computer will provide you with information that at one time could be gathered only through long hours of poring over books and publi-cations, expensive consultants selling competitive intelligence, and costly buying trips overseas. Today the Internet as a tool has almost single-handedly created global integration, and made us all research analysts. It has made the world seem just a little bit smaller, and has made it easier to access information with just a few clicks of your mouse!

Sourcing and the computer

It is probably important to start off by saying the computer does not do the sourcing—people do. They are using Internet service providers that need to be accessed through computer terminals. To know exactly what the Internet does and how it works is a topic that fills countless books in the marketplace today and those books will continue to change as the technology of the twenty-first century continues to develop. This textbook will not teach you everything about the Internet, but instead it will help you to understand how the Internet can aid you in successfully meeting the demands in the fashion cycle. Everything in this text is tailored to be fashion-industry specific.

So, what kinds of information should you, the designer, know about?

Gathering information to develop a line can be overwhelming. In order to keep this simple, I am going to break this discussion into two basic areas:

1. In the succeeding chapters I am going to provide you with a snapshot on <u>what</u> you need to research. Along with a brief overview, I will give you some

suggestions and starting points on where to find this information both in electronic format and hard copy if possible.

 2. Next I will give you some practical steps on <u>how</u> you can download the information you gather from the Net. Yes, this is a technique unto itself. Sometimes you will acquire so much good data that you might want to keep the files on your own computer hard drive rather than searching each time you need the information.

Oh yes, one last tip before we start this process. People often ask, where do I start? A quick hint is to always look at the past. Even though new and exciting data are available every day, taking a look at what made past lines successful—what fabric mills you have worked with, what finding companies you know, or what trade shows offer you the best buying and selling opportunities. Conversely, learning what caused problems can often be the best data you can gather, so don't be shy about digging into past sales or product lines. Learning about one's successes and failures often will serve well as a starting point for a designer. So determining your present needs and anticipating your future supplies often is linked to the past, knowing what worked and what did not. Maintaining a network of professionals to tap into is always a great starting place. In many of the exercises I will attempt to recreate typical scenarios fashion professionals find themselves in, as well as training the student for the "real world" case problems.

Understanding what to research will connect the whole team . . . Designers, Production, and Sales/Marketing!

Why research, who needs what information, and why and where do you begin?
Designing begins with a vision. Specifically, the vision consists of who you want to target such as a special consumer group, focusing on their likes, needs, and buying power with colors, textiles, and products that are exciting and new. Though you may think of visions in terms of colors, fabrics, and trends, they really start out with the healthiness of one's pocketbook. Simply put, a designer has to know what is going on in the world; so first we are going to address the economy, and the role the consumer plays in the economy.

Economic Research and Consumer Buying Power

Why researching for data in this area can help you . . .
As a designer you really need to know about the economic healthiness of the world. You need to know how people are doing financially as they make decisions on purchases, whether it is a home, car, or clothing. From a design viewpoint, if economic times are on a downturn, the garments you create should

reflect those attitudes. Your ideas and visions may focus on simple lines and durable fabrics during practical times. When economic times are booming, colors, shapes, and textiles may reflect bolder and more exciting attitudes.

From a production viewpoint, finding the most technically appropriate and economical manufacturing facilities can help you make or break a line. If a line is produced at the sharpest price, you give it to your customer at a smart price for the economic times at hand. Ultimately, the consumer is satisfied. Therefore you need to have a good look at what is going on in both the domestic economy and the international economy because it will let you know where to best produce your product lines. Manufacturing facilities are popping up in emerging economies every day, as technology creates greater shifts between hand needlework and automated production.

From a sales and marketing point of view, simply put, you need to know how people are spending their money and on what! The economics of the world can be best interpreted by the consumer's daily buying habits. Before you even think about designing a line, you have to think about the consumers and how and where they want to spend their money. This means you may need to know how to gather demographic and psychographic data.

So where do you begin to find answers to connect all those concerned in the design process? Let's have a look at where professionals begin. In the following chapters you will become acquainted with the who and why, and in the CD I will direct you to the specific link folders to many of the suggested sources. Next, you will find a quick snapshot of what kinds of information you will be expected to know how to gather and then how to locate this information using both traditional and nontraditional resources.

Economic Informational Snapshot for what to research and where to look

Suggested sources to find this information	Why?
Standard and Poor's Trends and Projections	Gives strong economic overview
Standard and Poor's Industry Surveys	Identifies industry growth/concerns
Consumer buying guide	Shows how and where consumers are spending their money

Daily newspapers	Illustrate consumer spending habits (e.g., *The Wall Street Journal*)
Business periodicals	Discuss economic shifts and issues worldwide (e.g., *Newsweek, Time*, and *Fortune*)
Featured authors/consultants/books	Provide researched concepts on consumer attitudes (e.g., Faith Popcorn's ***Clicking***)

Design Team Sourcing Needs Snapshot
Why researching for data in this area can help you . . .
As a designer, fashion trends and textile research are vital for creativity. Once the designer really gets to know the consumer, the next step is probably the most exciting. It is at this time that the designer starts to gather visions and inspirations and match them with sources that will provide:
• Colors
• Fabrics
• Design tools (e.g., graphics, clip art, and color services) that will enable them to produce exciting and innovative products that the consumer will appreciate 18–24 months into the future!

From a production viewpoint, the production manager must be certain that the fabrics and findings the designer has selected are available within guidelines of important quota restrictions, during the time the materials are needed, and even more important, to know the landed costs of materials.

From a sales and marketing viewpoint, this team must clearly understand the designer's vision and be able to develop a strong strategic marketing plan that will be unique and exciting for the consumer. The marketing team has one of the most difficult jobs: they have to build the bridge between the designer and customer. And if the sales and marketing team does not clearly understand the colors, the fabrics, or the silhouettes, they will never successfully pave the road for the consumer to buy. The line will have no direction or excitement and it will simply blend in with every other competing product. Ultimately, sales will occur by chance rather than consumer demand for the new styles and trends the designer presented.

All of these resources will be covered in more detail in both the traditional research section on libraries as well as in the handy links to access these publications or companies directly via the online link section on the CD. You will notice in each section below that I list the periodical or publication as well as why it is significant to the fashion researcher.

Designer Resources Snapshot

Suggested sources to find this information	*Why?*
Leading trade publications	Identify key trends, textile reports (e.g., *WWD, DNR, Bobbin, Knitting Times*)
Leading fabric councils and firms	Identify fabrications/use, care, and innovations (e.g., The Cotton Council, The Wool Bureau, or Burlington Industries)
International trade show directory	Locate trade domestic and international trade shows for textiles and findings
Leading fashion and color services	Focus on color projections fabric and fibers (e.g., PromoStyl, Tobé Huepoint)
Leading books on costume and history of costume	Details, silhouettes, shapes from the past often provide inspiration for lines in the future
Leading industry magazines and publications	Provide trend projections (e.g., *Bobbin, Textile Suisse, Knitting Times*)

Production

Why researching for data in this area can help you

As a designer even though the focus is to create garments that make men, women, and children look attractive, a designer also wants to be sure that the way the garment is mass produced maintains the integrity, fit, and durability of the original design and sample. Therefore, good designers confer with the production department to ensure the quality production of a line.

From a production viewpoint sourcing for information is vital in two areas:
Equipment and Manufacturing
It is essential for the production manager to know about the state-of-the-art equipment for both design and garment construction. From a business point of view the production manager knows that a well-thought-out investment in technology will produce a more profitable garment long term. Therefore they must be up to date on the latest computer systems and programs so they can maximize pattern making/ grading and marker making output. Additionally, they will take a firsthand look at the type of equipment needed to produce an item(s). Specific industrial machines cut construction time in half, and time saved is money earned; therefore, the production manager must be on top of all new equipment and changes.

Along with knowing equipment needs, a production manager must focus on the actual manufacturing facility. With manufacturing centers worldwide, the production manager must assume the role of an international trader, identifying:
• Overseas taxes, tariffs
• Quotas/customs processes
• Shipping time/freight-forwarding companies

From a sales and marketing point of view, with the U.S. government cracking down on unsafe labor practices, it is important to focus on where the manufacturing of products is taking place, and to emphasize quality of construction in the sales literature and marketing campaigns. Going hand in hand with promoting quality construction and care, the sales and marketing teams will want to promote the products that meet the U.S. marking regulations, which enable consumers to identify fibers and country of origin, a legal identification code that helps consumers identify the manufacturer and the international care symbols.

Production Snapshot
To locate overseas taxes, tariffs, quotas/customs processes, shipping time and freight-forwarding companies.

Suggested sources to find this information	*Why?*
WWD Buyers Guide	Identifies manufacturing companies
Companies and Their Brands by Thomson Gale	Lists companies
World Trade Center/finding programs	Connect international suppliers and manufacturers

Leading industry magazines and publications	Provide information about leading equipment and manufacturing firms
Government publications on tariffs and quotas	Identify viability of using overseas labor
Press kits, annual reports, and sales materials	Inform about new technology and leading equipment manufacturer systems

Sales and Marketing
Why researching for data in this area can help you . . .
As a designer you know that the consumers are buying more than a product, they are also buying an image. Therefore it is up to the designer/design team to not only know when the key designer markets, fashion shows, and industry releases occur, but also to make sure that you as the designer are accessible to the consumers. You and your firm must promote print and broadcast ads and special events, and support public relations activities that reinforce the image of your collection or line.

From a production viewpoint the focus is strictly on deadlines, deadlines, deadlines. The last thing a production manager needs as he or she juggles material and product shipments around the world, is not being able to deliver on time. A designer may have spent two years in the development of a line, and if the production manager cannot ensure the prompt and timely delivery of a product, the line is a failure only because it did not get to the consumer at the right time. Continuing to research tariffs, quotas, and shipping, just as the production manager began in the production process, prevails as the production manager's key responsibility.

From a sales and marketing point of view this research is essential for effective promotion.

Sales and Marketing Sourcing Snapshot
• Tools to develop strong sales
• Information to develop advertising strategies, including web page and catalog design
• Lists of companies to sell or promote products to
• List of key brand competitors and key retail store competitors

Suggested sources to find this information	_Why?_
Leading trade publications	Identify key competitors' advertising and promotion techniques (e.g., _WWD, DNR_)
Leading advertising publications	Review advertising campaigns and leading advertising/PR firms (e.g., _Advertising Age_)
World trade publications	Appropriate freight-forwarding companies, international sources, and other affiliations
Sheldon's Retail Guide	Locates retail stores and buyers and resident buying offices
Hoover's	Serves as an index guide to leading companies and so much more
Thomas Register of American Manufacturers	Lists small to large manufacturers

Now that you have a better understanding of what will be expected of you, in the next chapter I will walk you through using traditional sources for obtaining this information.

Hint—Go to the **Goodies CD> Chapter 1 What Is Sourcing> List of Suggested Resources Snapshot**

Notes:

2. Traditional Resources . . . Then and Now

Terms to look for:

Abstract

Database

Dewey Decimal System

Electronic library

ISBN/ISSN

Library of Congress

Periodicals

Primary sources

Query

Remote access

Secondary sources

Shopping sleuths

Specialized databases

Trade show

Traditional resources

Virtual library

Traditional Resources—Sourcing Then and Now?

So what are traditional resources for the fashion professional? In this chapter you will discover what the industry insiders know on how and where to access valuable information. Here is a brief list of some of the most common traditional resources that have been used by industry pros:

- Libraries—public and private
 - Examples might be local colleges and universities, corporate libraries, archives, and databases
- Museums
- Trade organizations
- Trade shows
- Fee- and non–fee-based service providers such as trend or color forecasting

Therefore, using **traditional resources** in the past meant obtaining information by physically going to a given source for information and answers. Today, however, everyone would agree that the most popular method for accessing this information is the quicker, nontraditional method—the Internet.

While the Internet has been around for approximately 20 years, fashion and business professionals have been leveraging its benefits only in the past decade thanks to advanced technology and systems.

Until that time, did designers consider sourcing? Sure they did, but it was all done manually. That meant a great deal of time was spent researching books and periodicals at the libraries. The fashion professional relied heavily on trade publications as well as other industry-driven events such as trade shows.

Additional information was also gathered by conducting surveys, or working with consulting firms to learn more about economic and consumer trends. This also included taking costly overseas trips to locate textile companies and manufacturing facilities.

Did it work? You bet it did, because everyone was conducting these searches in the exact same way. Designers were producing a line three to five times a year with everyone contributing to the process. Today, however, with the computer and the Internet acting as a *survey center, a consulting firm*, and even an *overseas travel agency*, the time to gather the data has decreased dramatically.

Not only are designers able to react in real time, but the results are an accurate reflection of their consumer demands. The best part is they can accomplish this with less expensive overhead. The bottom line is that now, thanks to a computer and the Internet, a designer can produce up to six to ten lines a year to achieve the true basic principle of marketing, which is to create customer satisfaction that will result in generating repeat business.

So, what exactly are the best traditional resources used by the fashion professional then and now? Let's take a look!

Traditional Resource Secret #1:
 The library

Although many things have changed, some do remain constant: the local library has always housed much of the data necessary for the fashion professional. While the conventional library is brick and mortar, many libraries have gone "click and mortar"; that is, libraries can be physical buildings but they also are virtual edifices without walls. This chapter will reintroduce you to the

traditional library and show you the resources you will need to look for in *your* search for information.

Without a doubt, walking into your local public or college library can be a wonderful, exhilarating experience or it can be overwhelming and daunting . . . starting with the process of where you should look first and how you begin researching.

Don't be ashamed or embarrassed about feeling inadequate, overwhelmed, or confused about where to start. It's easy. Go straight to the help desk. If you are new to the area, college, or even to a given library attempt to find out exactly what the library's specialty or focus is. You may need to inquire who the individuals are who use this library most.

In other words, you may need to discover the library's audience. Is your nearby library a small local branch with a limited budget and limited holdings or is it a major city library in a large metropolitan area? Once you consider the size of the library, start with the smaller branch until you get acquainted with the way the library functions. Then consider moving to a larger main library; a smaller branch library may not have the same resources available that a larger facility would offer.

For example, if you are in a city that excels in business or perhaps financial matters, obviously you can expect the local or university libraries to have excellent resources to match the demographic profile of their audience that will be business driven. Naturally you are not going to head to a library that focuses on the medical community and expect to find the latest copy of a major fashion trade magazine such as *WWD* (*Women's Wear Daily*)! So do your homework first by seeking out the right library source for the information you will need as a fashion professional.

Meet your new best friend . . . *your local librarian*
No matter how busy you are, there is one person you want to make time to get to know, your librarian. Yes, a good librarian can simplify your search for vital information.

My many years as an educator have taught me that the difference between finding a good answer and a great answer could be due to the help of your well-versed librarian. Trust me, you cannot underestimate the benefits of using a good librarian who is research savvy and who has the passion to serve. Great

customer relationship skills can make all the difference. Developing a relationship with a like-minded professional who will remember you can really make a difference. Can you imagine having someone who is always on the lookout for ideas, books, and information that will benefit you—wouldn't that be a dream come true?

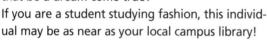

If you are a student studying fashion, this individual may be as near as your local campus library!

During the course of my preliminary research for writing this text and CD, I had the privilege of working with Brian Frasina. This young man had completed a portion of his undergraduate work in fashion design, while a greater majority of his work experience was in the library sciences. What a great combination of talents. Back when I first met Brian, he was assigned to the fashion design department as the library liaison. There wasn't anything anyone could ask for that Brian that couldn't locate.

Long after Brian had taken a position at another library clear across the United States, he would always stay in touch and send me an email about a book he knew I needed to read or a URL that I had to visit.

Needless to say, you don't have to be the department chair or a professor to

develop such a great working relationship. Finding and nurturing such a relationship can really be helpful when you need some specific information. Perhaps that old adage "It is not what you know, but who you know" really applies when it comes to librarians!

OK, so where do you begin your tour?
Where does the small businessperson or the fashion newbie or student need to begin to find the information they need? One of the first stops is your local public or college library. Let's

begin our tour by having a look at some of the specific traditional resources you will need to locate in your typical local college library. Much of the information we will cover may not be new to you; either way, consider it a great introduction or refresher to the basics of library usage. It all begins by taking yourself to your nearby library.

OK, so now that you have found a library, you are starting to wonder what's next. The best place to start is to determine how the library is organized—is it *Library of Congress* or *Dewey Decimal?* Oh, no . . . is your head starting to spin with flashbacks from a high school research paper fiasco? Never fear; remember to ask your new best friend, the librarian, for assistance.

Now, you don't have to be an expert in the Dewey Decimal system to function in the library. We will do a simple topical review of what is available in most libraries for the fashion professional starting with how the library is organized and what acquisitions you might expect to find.

Library Classification Systems: Library of Congress or Dewey Decimal

Perhaps it has been some time since you have had to conduct research in a library; therefore, a brushup on how to navigate the library card catalog may be useful. Simply put, the method of how the information is categorized will help you determine where the information can be found on the shelves. The goal of any system is to attempt to keep items with the same subject matter together in a logical order.

For example, in the Library of Congress method FINE ARTS is listed under *N*, while the Dewey Decimal places FINE ARTS under 700–799. Many college libraries are laid out in the Library of Congress format. Every item in the library is coded with a **"call number"** based upon the Library of Congress classification system. Deciphering what a call number represents is not really all that complicated. In fact, it is read one line at a time. The books themselves will be arranged in alphabetical/numerical order. (See Figure 2-1 for how to read a typical call number.)

Once you know how the library is organized and arranged, you can easily begin to navigate the library and find what you are searching for. In the case of the Library of Congress classification system you go to the catalog to find information on your chosen subject that will be alphabetically, then numerically listed.

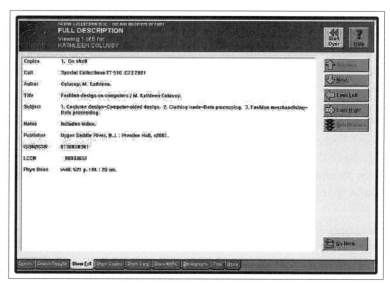

Figure 2-1

Most of this information at the library will be found on computers within the library via *Online Public Access Catalogs* (OPACs). Viewing these screens is much like looking at the old manual card catalogs from your grammar school daze—I mean days. Once you have become reacquainted with this, you can use this information to go online from any remote access computer and begin your search. *Remote access* implies that you can visit another library without walls instantly—a *virtual library*—via a computer and access your information online! Your librarian will be only too happy to walk you through the basics on how these work. At the end of this section, I will give you an overview on how to access information using a database.

ISBN or ISSN

Another way to locate a specific publication is to use an index that contains various publisher numbers such as the *ISBN* (International Standard Book Number) or the *ISSN* (International Standard Serial Number). It should also be noted that both music and government documents have their own set of call number indexes.

Books are located in several ways, either as open circulation or as reference materials. Open-circulation books are available to check out, while reference materials must be accessed only at the library.

What else can I expect to find in my local library?
Let's take a look at some of the other items you can expect to find on hand.

Dictionaries, Encyclopedias, and Thesauruses as well as other reference materials

Of course you can expect to find the usual collections of encyclopedias, the-sauruses, and dictionaries. Most categories of books acquired by the library are driven by the focus of the library's intended audience. For example, if you are at a college studying fashion, it is obvious there should be available dictionaries about textiles or even related industrial equipment.

Fashion books are found in the open-circulation area of the library, whereas dic-tionaries and encyclopedias are located in the area of the library known as the reference section. The reference section is separate from general circulation because these books remain permanently in the library. Colleges and universities also have a reserve section where faculty can select specific books to be isolated on reserve so that everyone in the class can access the information.

Periodicals: Periodicals are publications issued at regular intervals (e.g., daily, weekly, monthly, quarterly, etc.) and are intended to continue indefinitely. They include newspapers, magazines, and journals.

Libraries will have a <u>Reader's Guide to Periodical Literature</u>, an index that is arranged by subject, including articles found in most common popular maga-zines. Magazines are broken down into categories. Here is a snapshot of what is available:

Magazine Categories

- Scholarly Journals—formal publications written about new ideas or on specialized research findings (e.g., *Costume: Journal of the Costume Society* is published for the Costume Society by the Department of Textiles, Victoria and Albert Museum: 1967/68).
- News/General Interest Magazines—*Time, Newsweek.*
- Popular Magazines—*Elle, Vanity Fair, People.*
- Trade Magazines or Journals—*Bobbin.*
- Sensational Publications—publications such as the *National Enquirer* are not usually found within public or academic libraries.

Formats vary greatly for magazines and journals, ranging from extremely formal and of a serious nature to slick glossy formats for popular publications.

Many of these resources can be available as bound hard copies, or on CD-ROMs or online. What distinguishes each of these publications are the writers and reviewers of the content. How credible are they? How credible is the publication? Is the source reliable, objective, factual, and of a higher quality and standards?

Assigning Value to Information

In the academic world as well as in the industrial arena, value must be assigned to data. Libraries refer to the types of sources that the information was gleaned or obtained from as primary or secondary sources.

Primary sources provide firsthand information of the original words by the creator or from eyewitnesses. This would include creative works; for example, poetry, drama, novels, music, art, and films, as well as original documents such as interviews, diaries, speeches, letters, minutes, and film footage.

Determining the viability and credibility of the data will have a direct impact on your findings. Sources that will add credibility to your research would be statistical data, case studies, conference papers, technical reports, and research papers published in scholarly journals or from speeches given. Including and citing this data will give you more credibility as a researcher. We will discuss this topic more in depth and instruct you in determining a litmus test for the data you find in *Chapter 4.*

Secondary sources contain information that has been reviewed, evaluated, analyzed, or interpreted from primary sources. An example might include criticism and interpretation of creative works given by other authorities on the subject matter. You may also consider useful interpretations of original documents, such as biographies, historical analyses, textbooks, encyclopedia articles, and summaries and reviews by recognized reliable or credible sources. For now, let's continue our tour of what else you can expect to find at the library.

Databases
Finding solutions in the library using any database

All good research begins by asking the right questions. Asking questions, or queries in librarian speak, means posing your questions so that you can find answers.

The first question is where do you begin to look? Do you head directly to the stacks of books in circulation? Where do you begin seeking answers?

Figure 2-2

A *database* is a collection of information. Databases are available for articles from magazines, journals, and newspapers and can be obtained by using the library's online database systems. Check with your local college or regional library to determine which ones they subscribe to. Selecting appropriate databases can be daunting from the many choices available. For example, one popular software is by Sagebrush Corporation, and is called *Athena*. Athena is the best-selling library automation system for Windows. Athena provides circulation, searching, cataloging, cross-platform capabilities (Macintosh and DOS), and related functions for large and small libraries and school districts. Optional modules include Spanish and French interfaces and Weblink, which allows patrons to search an Athena collection via the Internet. There is also a sample working exercise on the Goodies CD> How-to use ATHENA software by Sagebrush Corp.

There are a few things you will want to think about before you choose a database. First, decide how you will approach your topic. Did you know that information found in online databases is often organized according to the subject or discipline? Examples of this might be business, anthropology, architecture, and so on. In addition, the database will tell you what type of publication the information is from, such as newspapers, trade publications, or scholarly journals. Many fashion professionals rely on trade shows and conferences to keep up with the current trends; therefore, having some of this information available locally at the library can be a real bonus!

Selection of databases offered at a given library is determined by the library staff based on perceived need. Obviously the library's goal is to best reflect and serve local community needs. As you become more familiar with which databases would best serve your needs, having a dialog with your librarian and offering a recommendation is completely appropriate.

Databases can be accessed on-site or even online from any computer, providing your library offers off-site access to this information, so be sure to inquire. I have included a list of several sources you may wish to become familiar with that may hold the key to a successful query.

Databases, Directories, and Indexes *free and available for a fee*
As noted earlier, library collections are frequently based on perceived need, not to mention budgets! Every library must choose which services and databases to subscribe to that would suit its clients' needs.

You will soon discover that some of the best services available to any library can be quite pricey. This means that the database of information comes at a cost. This is good news . . . typically colleges and universities will make this pricey and "gated" information available for their students as part of the cost of tuition.

Gated sites are often the ones with the most sensitive and useful information. You will want to make special inquiry into what database subscriptions your library has available.

*Don't forget, this is fee-based information purchased by the library for your use. In the case of a college or university library these resources may be available from a remote location by using a **gated access code** or **password** online, so be sure to inquire.*

Specialized Databases—There are a variety of databases available in several subject areas ranging from business, economics, art, interior design, fashion, and more. Although I have listed several, you may wish to inquire about their availability in your area.

Remember, most of these premium databases often require a pass code to access. These services can be available in several different formats, so be sure to consult with your local librarian. Most of these databases/CDs have several ways to access the information, including keyword searches as well as advanced methods for refining your query. This means becoming familiar with Boolean logic.

Boolean Logic . . . *Librarian-Talk* for How to Access a Database

Finding these answers in the library need not be as difficult as it first appears; you will soon be accessing information and assistance via a traditional or a digital card catalog. Today's library computers utilize Boolean logic and truncation concepts to help you locate or refine your search for information.

So, if you are one of those people who are research-phobic and are beginning to twitch or are starting to break into a sweat—relax! These techniques are so vital to your success that I have dedicated an entire chapter to teaching you how to successfully use these methods of locating data. For now I will briefly introduce you to these concepts, while in Chapter 4, in the section on search engine savvy, I will provide you with detailed practical advice on how to successfully use Boolean logic and search engine math just like a pro would. For now, know that libraries are filled with a wide variety of different databases to aid you in your search for solutions.

Boolean Logic Overview . . . How to search in the library

Using Boolean logic is how a database or a collection of data is accessed. Databases can be arranged in a variety of different formats. It is helpful to remember that while sections of databases may on the surface appear to be very different, all databases can be accessed in the same way. Therefore, familiarizing yourself with the following concepts will go a long way when you do advanced searches online later.

Boolean logic is an integral part of traditional and nontraditional research. In this section I will provide you with a snapshot of how Boolean logic works, and will go into much greater detail in Chapter 4, on how to successfully use this knowledge when conducting online Internet research.

There are three main ways to conduct a search:

1. *Keyword Searching:* This involves entering a specific keyword or combinations of words in the *"Search Dialog Box"* that will take you to the closest answer you are looking for. A Search Dialog Box is typically found on the home page of the database you are using. The trick is to enter the most specific word to narrow your query (question) to get the best and the most relevant response.
2. Next you can narrow your search using **Boolean operators**. These operators are case-sensitive words such as *AND, OR,* and *NOT.* Using these Boolean operators will broaden or narrow your search for answers.

For example, say you need to find articles on costumes worn during the Renaissance; you would enter "Renaissance AND Costume."

3. *Phrase Search* requires the use of quotation marks before and after your words: "Renaissance Costume."

Ranking Relevance and Date Range

Your next choices will be how to *sort* your search. Search results are most commonly sorted by ranking the relevance of the search, and in most cases for articles this would refer to the date of the article. Frequently you can even request a date range for your article to be conducted *"From"* a certain date *"To"* a certain date. This can be pivotal when conducting time-sensitive research on trends.

Much of the information you will need is typically available in several of the following formats:
• Traditional—books, magazines, newspapers, and journals
• Database CD—microfilm that is located on-site
• Databases, abstracts, and indexes—on-site, with membership, or accessed off-site via Internet and using an access code or password

Don't be afraid to ask questions if you do not understand the scope of the database you selected. For example, ask:

• Does this database cover the subject area (discipline) I really need, or is there a better, more focused database?

• Does this database provide indexing for the date range I need?

• Will this database point me to or provide the full text for articles written during the time period that is appropriate for my research need?

The truth is there is no "magic formula." A lot of your solutions will come from trial and error, networking, and even asking the right questions.

Other Considerations

What if you are having trouble finding a certain book or perhaps an older edition of a certain periodical—where do you turn? You may find that your next step should be to request an interlibrary loan. Most libraries offer this type of service; to be sure, check with the librarians for availability.

Databases Useful for the Fashion Professional
How Do I Choose a Database? Which Ones Do I Use?

Selecting the correct resource to use for your research can be overwhelming, intimidating, or just plain frustrating. However, before choosing a resource, you must define at least a preliminary topic, or have a general idea of what you need to find out.

The choices you make every time you start researching may be as unique as the topic itself. A little knowledge about the differences among these resources and the types of information that they contain can help you decide. Often, a combination of resources, with a particular emphasis on one or two, will be the key to unlocking the answers to your queries.

Below I have listed several key databases you may wish to know about. While this is far from complete, it certainly will give you a great start on conducting research.

ADAM Art, Design, Architecture and Media Information Gateway.
Artifact—Arts and creative industries database.
AMICO—Over 60,000 works of digitized art representing works from Europe, ancient cultures such as the Pre-Columbian, Greeks, Asia, Africa, and others.
ARIAD—Allison Research Index of Art and Design database.
Art Index—Bibliographic database of art and design.
Corbis—images may be available at your local college for your use as a student in a design graphics program.
Databases for Art and Design:
• **ASAP**—Expanded Academic ASAP indexes over 3,000 magazines and journals.
• **Dialog Newsroom**—Online gated full-text articles.
• **Factiva**—More than 6,000 business and trade publications including *The Wall Street Journal*.
• **Lexis-Nexis**—Full-text articles from magazines, newspapers, trades, wire services, and more on current events.
• **Omnifile**—Includes 2,700 journals from education to popular magazines.
Design and Applied Art Index (DAAI)—provides access to the articles in over 500 design and craft journals and newspapers published since 1973!
Design Online—Resources of fine furnishings to the interior design trade including manufacturer's catalogs available online 24/7.
Dissertations—There are numerous databases and indexes with offerings for these works and dissertations on a variety of subjects. Depending on the college

or university, some have on file a digital catalog of their collections that can be accessed by typing a keyword in the dialog box to view the offerings available.

Electric Library—A general database that provides access to hundreds of thousands of sources such as magazines, newspapers, and movie, television, and radio transcripts. The best feature of this database is that it is not limited to text only but has access to a database of pictures and images as well.

Facts On File—Provides access to collections of other databases such as:

> **World News Digest**—Includes newspapers, periodicals, journals, and government online sources.
>
> **Issues & Controversies**—Objective analysis and explanations of opposing views on controversial or complex topics.
>
> **Today's Science**—Reference on current topics in science, technology, medicine, and the environment.
>
> **World Almanac**—Best known and respected database for over 130 years on a variety of topics and subjects.
>
> **ProQuest**—Premier online information service to summaries on articles from over 8,000 publications, many with full text and images available.
>
> **SIRS Researcher**—Thousands of full-text articles on more than 1,500 domestic and international sources ranging from historic to economic to social-cultural.

Fashion Databases: (gated & nongated)

> **Apparelkey** (gated)
>
> **WGSNedu** (gated)
>
> ***CDs, URLs, and other nongated offerings:***
>
> **Introduction to Textiles** *(multimedia training package)*
>
> **Just-Style**
>
> **MINTEL Reports** *(essentials and retail intelligence)*
>
> **Techexchange**
>
> **Trend Services**—Include WGSN, Snap Fashun, Pantone, Fashion Snoops, and many others. Frequently these can be in a variety of different formats from hard copies, CDs, and slides, to multimedia DVDs and videos depending on the company.
>
> **Gales**—Hard-to-find personal data, biographies, and much more.
>
> **Grove Dictionary of Art**—Contains over 45,000 articles on every aspect of the visual arts, including painting, sculpture, graphic arts and more.
>
> **HW Wilson Omni File**—This gated service is multidiscipline and has full-text articles dating from 1994.
>
> **Hoover Online**—The access to the gated sections of this fantastic resource includes full company profiles, history and strategies, market position, competition, and overall financial health.

Inteletex—Covers global textiles, with full-text articles from several leading trade publications.

International Designer Directory: The Fashion Guide

Oxford Reference—Available in a wide variety of different subjects.

SIRS Renaissance—This is a specialized database that searches over 700 sources to find current information on arts and humanities topics such as film, culture, literature, the visual arts, performing arts, religion, TV, architecture, and more.

Trade Directories—There are several leading directories and indexes available for reference, including the yearly edition of the *Fabric Buyer's Directory*, as well as the *Fashion Index* and *Clothing Industry Yearbooks*.

Special Collections

Finally, you may also expect to find in your libraries special collections that can include:

- Collectors or special editions
- Design files
- Historic books
- Lecture notes
- Multimedia collections of slides, videos, and/or DVDs
- Samples of student projects, portfolios, dissertations, or thesis collections

Once you have become acquainted with this you will then be able to use this information to go online from any remote access computer and begin your search. **Remote access** implies that you can instantly visit another library without walls—a **virtual library**—via a computer and access your information online!

Keep in mind that much of these sources may be available to you as a student at no charge and the access codes may be available for you to use from another computer at a remote location. This means you can access the information from the comfort of your home or dorm room using your computer and the Internet. So while you are in the library, don't forget to inquire what services are available to you online from a remote access!

Traditional Resource Secret #2: Museums and Art Galleries

Where else can I go for ideas, information, inspiration, and insight?

Renowned Florida artist Gary H. Tepper's art studio: Studio 37a

Fashioned professionals know that ideas, information, inspiration, and insight can come from a variety of sources such as museums and art galleries. In Figure 2-3 you can see work from renowned south Florida artist Gary H. Tepper. His studio has

Figure 2-3

From the series *Yid Du Partizaner (Soup)* by G. H. Tepper

I saw a Hero yesterday, from more than half a century away
Bent low he was, above his soup.
Cabbage, carrot, and beet root.
Steam and black bread helped him drift
Away; Back to a very foreign soup, and day. That foreign soup beyond the veil of time
Was served clear and thin, no challah, no red wine.
Surrounded by the gray green foe. In a dark
Cold forest long ago, soup was ladled from
An ammunition can into a dented rusting pan. Sitting hard against an Eastern European tree.
Boot heel dug deep into the rich hard mud.
A pan of pale soup balanced on the knee,
A snare of piano string. A Mauser, for one's serviette,
Party favor for would be gray green kings. That is proper etiquette! Early mornings, off he
 went to be
An uninvited guest at a gray green luncheonette.
That soup is thick, rich, and served blood red!
Justice ladled full, sharp, cold,
Shock to a most evil gray green foe. But sadly, he carried away a fallen friend.
No Rabbi to say a prayer, No wine for a blessing to fill the air.
Just a shallow grave.
Closed a comrade's eyes, kissed his forehead, and cried.
Another Jewish partisan has died. A gentle silver face brings a hero back
Through the mind of time to a much safer place.
Soft hand upon his hand. Home old man.
Arm in arm, she and he.
Off they go speaking low of soup and bread and days passing glow. I saw a hero yesterday,
 from more than half a century away.

a physical location in Dania Beach, Florida, as well as a virtual address at ***http:// www.Studio37a.com***. Gary's work showcases a wide range of styles from pencil to oil on canvas.

Fashion professionals are always interested in what events are in museums within their geographic region as well as around the world. For example, the significant finding from Howard Carter's 1920s exhibition to Egypt which gave the modern world its first glimpse at the grandeur of King Tut's tomb will be traveling around the United States. Exhibits like this and others offer some of the most exciting exhibitions that museums sponsor or host. To further celebrate these exhibits or events museums will self-publish or provide lavish image and text documentation of a given event or exhibit. Aside from being a great source of revenue for the museums, it makes for an exceptional resource of ideas, inspiration, and information to the fashion professional.

Unfortunately, these books may be available only at the museums or from their related distributors or booksellers, and may not be available at your local library. You will find that museum exhibitions can be theme-based or tribute-based events.

The more successful the event is, the more likely for it to travel to other museums across the United States or around the globe. Books that highlight the exhibit can be an invaluable resource to the designer. The exhibits mounted by MoMa (Museum of Modern Art), the MET (Metropolitan in New York City), and the V & A (Victoria and Albert Museum in London) are legendary! One visit to their websites will link you to the current and future exhibitions along with the ability to purchase the accompanying texts when available. Examples of recent exhibits that travel from museum to museum have been the tribute to Lady Diana and the career retrospective originally hosted for Mary McFadden by the Allentown Museum of Art.

Never underestimate the power of these publications for generating ideas! Major museums such as the Victoria and Albert in London or the MoMA in New York City have a treasure-trove of ideas waiting to be explored.

Traditional Resource Secret #3: Local Bookstores
Another great suggestion is to visit your local book sellers and "resellers." I have found that sometimes an older book that is out of print may provide terrific ideas for accomplishing a particular technique you want to master.

Figure 2-4

Traditional Resource Secret #4: Travel

Of course, nothing beats traveling . . . ask any fashion guru or arbiter and they will tell you that exploring different countries and cultures is perhaps the best way to garner fresh new ideas and inspiration. (See Figure 2-4.) You will learn the secrets of how fashion professionals use their travels to enhance their design process later in Chapter 6.

Traditional Resource Secret #5: Cultural Events, including Film and Theater

Cultural events, including film and theater, are great designer resources for inspiration. Who hasn't been impacted by a movie? Movies have inspired a plethora

of products, services, and trends scooped up by the world of fashion. Every generation has in their collective consciousness an iconic image of a star wearing an article of clothing, an accessory, or shoes that define an era. Examples abound from Gilbert Adrian's famous dress for Joan Crawford that simply became known as the Letty Lynton dress, to Julia Robert's *Pretty Woman* red evening gown. Let's face it, SA (7th Avenue) is still mourning the end of an era when the TV show *Sex and the City* went off the air! Needless to say, inspiration abounds from Hollywood and the music world.

The fashion professional should never underestimate the value of attending cultural events such as the theater or gallery openings. While it may seem a luxury to some, it can become a valuable insight or source of inspiration to another. Today, as in the past, keeping up with cultural influences on fashion is nonnegotiable.

Traditional Resource Secret #6: Industry Trade Shows

Attending trade shows and industry conferences is another way to solicit ideas and keep ahead of the current. A specialized event often hosts seminars and valuable training, as well as providing a chance to preview the latest trends in fibers, fabrics, apparel, and technology.

Traditional Resource Secret #7: Paid Industry Experts

When you realize you are in over your head or perhaps if you conclude that your time could be better spent analyzing what to do with a collection of data instead of gathering the data, it may be time to turn to the experts. In the case of business and marketing and of course trend forecasting, there are a plethora of companies ready to fit the bill.

Shopping Sleuths

The next thing you may wish to consider are services that are available for your company to use that will assist you in your market research. Can you imagine

that there are men and women from every walk of life who are paid to go shopping for a living? Your first thought might be, who are these people? Your next thought could be, where do I sign up? There are companies and organizations that hire individuals to gather very important customer psychographics by going undercover as shopping sleuths, such as the Mystery Shopper Organization.

A *shopping sleuth* is an individual hired by service providers such as Mystery Shopping Providers (**http://www.mysteryshop.org**) on behalf of another company or client for the sole purpose of gathering vital information on the consumer in the act of "shopping." Companies can engage (hire) and schedule men and women as mystery shoppers to visit a business either locally or literally around the globe to observe the "shopping ritual of the consumer."

The mystery shopper will be instructed to compile information through a variety of means; data are collected on everything from customer service to comparison shopping. The types of information they may be expected to gather include both observation and conversation. For instance, they may quietly enter a store and determine how informative and helpful the sales staff is.

This information is garnered in a variety of ways, including going undercover to a given retail source and purchasing and then returning the merchandise.

A further requirement for the mystery shopper may be to observe how the products are merchandised, as well as how the merchandise is perceived and received by the actual retail customer. For example, the shopper may note how the merchandise is handled, what is rejected, what is purchased, and even how many items are purchased.

One final aspect of the mystery shopper's job may be to evaluate the personnel for customer service skills and product knowledge. Typically they narrate their findings in written reports, or with the use of audio or video recording devices.

The information gathered by organizations and companies on a grass-roots level such as the one just described can be a vital link in the production process. The analysis of this information can then be applied and ultimately enhance a company's bottom-line profit margin and overall customer satisfaction.

In a recent article for *Metropolitan Magazine* in February 2005, entitled "The Holly Whythe of Retail," best-selling author of *Why We Buy*, Paco Underhill, was interviewed. His company, Envirosell, lists a virtual who's who of retailers as its clients, such as Starbucks, The Gap, Selfridges department store, and even the U.S. Postal Service. Envirosell is a behavioral market research and consulting company that focuses on the problems and solutions for retail design and the future of Internet shopping. According to the article, Underhill describes his customers in three categories, "retailers who call us in as part of store development, or for contrasting a store with a new prototype . . . to fast-moving products such as Kraft or Coca-Cola who want to look at how their particular category is being shopped at the point of sales . . . to banks, government agencies and cultural institutions . . . where they look at the intersection of where people, space, products and information systems interact." Underhill goes on to state that his company uses similar investigation methods to those described in this text to obtain information for his clients:
• Observation
• Conversation
• Investigation (traditional research)

Finally, Underhill makes one profound observation that the main function of today's research is to gather information not necessarily to serve new markets but, in his words, "to steal someone else's market." Today's researchers are often relegated to assisting their company to achieve the lion's share of the consumer's purchasing power! This is not to say that research methods are simply

about "dog eat dog." Clear information on consumer buying habits and motivations can instead result in a validation of what is working in the product development process. Creating the impetus for change to improve a product or service garners consumer loyalty by offering products or services a cut above the norm or simply adds value to the shopping experience!

So What's Next?

How to determine or analyze your findings . . .

One of the hardest things to do is to sift through mountains of data and determine what information is useful and what information is not necessary.

Below you will find a sample critical evaluation guideline for determining the value of the information you have found. It is very simple to follow and by no means inclusive; however, it does provide you with a widely accepted guide for what is valid and what is not. While there is no secret formula for success, there are key indicators that the materials you have selected are credible.

Research Guideline

1. How has this work been evaluated?
2. Who has evaluated this body of work?
3. Who is the author, what are his or her credentials?
4. Is the author considered credible in his or her field?
5. What do you know about the publisher of the document?
6. Is the work considered to be:
 a. Relevant
 b. Timely
 c. Logical
 d. Reasonable
 e. Objective
 f. Ethical
 g. Error-free
 h. Clearly organized
 i. Accurate
 j. Of good quality
 k. Authentic
7. Can the work be verified by at least two other sources in the same area?
8. Does the work provide bibliographies?
9. If you are using online research, is the website a:
 a. .com
 b. .net

c. .org
d. .edu
e. .gov

Clearly, the last three choices have a higher value than a .com or a .net extention, but not always. Using these simple guidelines to ask yourself—have I found the best information available?—can make a world of difference in your outcome objectives.

Now that you have a better idea of where to look, in the next few chapters you will learn the ins and outs of how to look for information.

Hint—For a quick glance at other things you can expect to find at your local library or even how to locate a virtual library, refer to the **Goodies CD> Chapter2>** which contains:
1. Libraries Online Goodies
2. Annotating Your Research
3. Basic Business and Marketing Sources
4. Encyclopedia-Dictionary-Clichés and More
5. Research Guidelines
6. How to Use ATHENA Software by Sagebrush Corp.

Notes:

3. Using Nontraditional Resources . . . the Internet

Terms to look for:

Browser	Interface	Protocol
CAD/CAM	Internet	Server
Channel	Intranet	Service provider
Deep Web	Modem	Third-party software
DSL-broadband	Multimedia	Turnkey systems
Domain name	Netiquette	URL
Download	Off-the-shelf software	WINZIP
Email	Platform (MAC, PC)	Wireless
File format	Plug-in	World Wide Web (WWW)
Hypertext/Hyperlink	Proprietary software	

The purpose of this chapter is to make you familiar with the Internet as a resource for the fashion professional. Thankfully, today most fashion professionals are probably well acquainted with the Internet. However, to be sure you have a grasp on some of the basic concepts of the computer and the Internet, the above list of terms includes all of the concepts that will be covered in this chapter. You should review the outline, then if you feel confident of the subject matter, you may opt to move on to Chapter 4.

Quick Reference Glossary for Basic Internet Terminology

Located on the accompanying CD is a handy reference chart for you to review the Internet-related terminology. Go to the Goodies CD>Appendix>Glossary of Terms>Internet Geek Speak and search alphabetically for any words you have forgotten the meaning of or perhaps are unfamiliar with.

- What is the Internet?
- What is the World Wide Web?
- What type of information can I expect to locate on the Web?
- What kind of interface should I expect to find?
- What would be my equipment needs?
 - Hardware, software, storage devices, auxiliary equipment, and services?
 - What types of applications (software) should I have?
- What about file management issues?
 - How can I download a file?
 - How and where should I store the data I find?

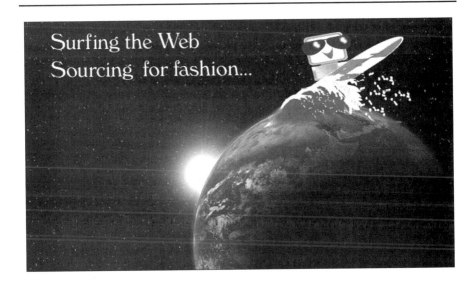

- What are some of the common file formats that I can expect to encounter?
- What are some important terms that I may need to become familiar with?

Nontraditional Resources for Understanding the Internet
What is the Internet?
The **Internet**, often referred to as the Net, is a worldwide network of computers. Consider it like a giant telephone system that allows people to easily communicate with one another, no matter where they live. How effectively one can speak to someone else depends on the equipment both parties own. But, generally speaking, whether your computer system is a new state-of-the-art high-speed computer or one that is a few years old, the results will be the same. You can be connected to the global marketplace and communicate with people worldwide.

While much of the data you will be researching is available in hard-copy format via traditional resources such as those found in the library, why not let your computer take over and make your life a bit easier? Finding this data online via computer gives designers an "instant library" right in their offices. It is as easy as clicking a mouse. Using the Internet is like having a research staff available for your assistance 24/7! Many people believe that the *Internet* and the *World Wide Web* are interchangeable terms. However, there are important distinctions between the two.

What Is the World Wide Web?
The **World Wide Web**, which you often see abbreviated as WWW, or simply as the Web, is a huge interconnected library of data or information. What the Web

does is connect all the people who are on the Internet, and provide an easy way for them to gather information. The term often used for moving around the Web is *surfing*. The word means exactly as you imagine—moving around from spot to spot allowing users to talk to one another, gather data, and generally explore new areas of interest. Much of the information is easily accessed; however, often for the fashion professional who requires some fairly specific answers, the Internet may provide only superficial answers to queries.

Gathering subject-specific information is referred to as "mining the Net" or **"deep-Net fishing"** or **"deep Web."** The information is there, but it requires a few more savvy research skills to locate it. The purpose of the next section is to review the types of information you may be searching for. Then, the next chapter will walk you through the specifics of how to mine the Internet for that information.

What kinds of information needed by the fashion professional can be found on the Web?

The information you find can be as *"intense"* or *"specific"* as searching for economic news, stock quotes, or company profiles. The Internet is as *"entertaining"* as game rooms or chat rooms, where you can just sit back and talk to someone on most any subject. For even the most casual users the Web merely is a great substitute for Uncle Sam's postal service if they sign themselves up with an *email address*, which will allow them to converse back and forth with people, and to even send data/information files.

For the fashion professional or the designer who is considered a "power user" the Internet and email can be both a time and money saver. Believe it or not, as manufacturing firms are forever springing up in developing nations worldwide, email has become the most efficient method to transfer information. It is both low cost and immediate with the use of a phone line that is accessible from even the most remote location.

Simply by the click of a mouse, a pattern can be emailed from a U.S. design firm to its Costa Rican manufacturing facility. That one click saved someone from packing the patterns in a tube, running to the mailbox, paying for the shipping costs, and waiting for the pattern to arrive in Costa Rica!

What kinds of information should you, the fashion professional, know about?

Gathering information to develop a line, for example, is a typical task for a fashion designer or product developer. Finding this information can at first seem overwhelming. In order to keep this simple, we are going to break down the

discussion into a few basic areas of information, beginning with what equipment you will need.

What equipment do you need before you begin?

To start, you will need a ***modem*** (or a device that connects to your phone line that enables your computer to connect to other computers via the Internet). The method used to connect is referred to as standard traditional ***"dial-up"*** or as ***"broadband"*** (also known as ***high-speed DSL***). Ask any fashion professional today and he or she will tell you to only consider access from your home or office with a DSL line. ***DSL*** (Digital Subscriber Line) is no longer a luxury for the fashion professional; time IS money. DSL is the fastest method for accessing and transferring data, while traditional dial-up, especially for uploads and down-loads, can be excruciatingly slow and frustrating. Next, you will need a Web ***browser*** (a software tool to enable you to look at the Web) that you will receive from your service provider. Service providers are companies to whom you pay a monthly service fee for connecting your computer to the Internet. Examples of ***premium service providers*** are MSN, America Online, and Earth Link. The secret is to find the service provider that meets your needs and budget. Traditionally, businesses have their own server (equipment) to connect you to both the intranet (or in-house networking) or directly to the Internet.

In addition to needing a computer with a modem and a service provider, today you can also consider the alternative of going wireless. Wireless makes using your laptop, Blackberry, or PDA instantly accessible to the Internet.

What type of interface can one expect to find on the Internet?

The layout and contents or ***interface*** of a browser or even a company's home page may vary. Many are ***"multimedia"*** (sight and/or sound) with interactive "hypertext and/or with hyperlinks." Hyperlinks and hypertext occur when the cursor changes its appearance to indicate more information on that subject is a click away. Often these links will connect you to either another part of the web-site or to a related website outside the site. The best way to get the feel of a site is to move your mouse around the screen and look for either a change in the cursor—for example, from an arrow to a "hand"—or for text that is a different color from the rest of the document. Most links will be very user-friendly with simple instructions for you to simply ***"click here"*** to get more information.

In Figure 3-1, notice that the main menu of a service provider is very similar to the main menu options you have been working with on a typical word processor. Several familiar pull-down file menus are shown.

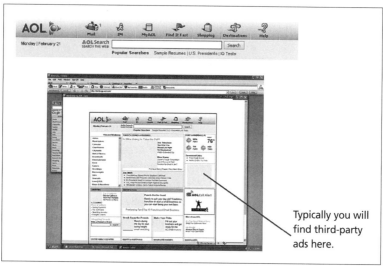

Typically you will find third-party ads here.

Figure 3-1

Did you notice the same main menu options such as **File, Window, View, Help, Print,** and **Font,** as well as **arrows** for going **back** a "page" or "site" as well as **forward**. Looks familiar, doesn't it? Are you starting to notice the menu similarities common to most computer software programs?

Once you log-on to your browser you will notice that there are also a variety of **"channels"** for you to choose from. Channels are sites that are categorized by topics; for example, Shopping, Sports, Weather and Travel—just to name a few. (See Figure 3-2.)

To find a particular business or source you need to type in the correct "Web address." This is similar to dialing a phone number. For example, you must follow a particular **protocol** for typing in the address. You will type in the website address in the field box located on the top portion of your screen. For instance, you may type **http://www.ComputersandFashion.com.** (See Figure 3-3.)

The information on the front end is called a **URL** or **Uniform Resource Locator**, followed by the name of the website known as the **domain name**, followed by a period and the abbreviation "com." Sometimes you will discover that the address of the company is **"case sensitive"** and requires you to avoid spaces, or to use capital letters. Other times the last three extensions of the website might not be ".com" (".com" stands for a commercial site).

Figure 3-2

There are several other frequently used extensions such as ".org," which is typically used for sites that are non-profit organizations. The ".edu" extension is used for educational institutions, and ".gov" for the U.S. government. Countries are indicated by an abbreviation for the country such as ".fr" for France or ".jp" for Japan.

Figure 3-3

Once you have typed the correct address, you will be taken to the *"home page"* (or the starting point) of a company's website.

Email Accounts

Most service providers will give you a "free email" account. Today it seems everyone is familiar with how to access and use email. Even most companies where you work or the college you attend provide you with an email account.

If for some reason you do not yet have an email account, there are numerous sites that will provide one. An example is **HOTMAIL.com**.

I suggest you have two accounts: one for business purposes and one for personal use. When choosing a name for your business email account, always try to use your name. For example, I use *KColussy@Hotmail.com*. This is easily recognizable to clients. Avoid the quirky personal names. Trust me, your client will not know who X-68 is, so avoid the *funky* names.

As a sidebar, don't forget to use **"netiquette,"** which is a polite style of messaging online. This is imperative when sending emails for business. You never know who will have access to what you send. Be sure to show some prudence and discretion when writing. Don't send anything you may regret later! *Did you know that what you send can be considered "contractual" in nature?* So, beware of what you do say—it can and may be used against you!

Email can truly make your life so much easier, so use it wisely, and be sure to make a file folder for email YOU wish to keep a record of!

The main feature of the Internet you will be using as a fashion professional will be a search engine. There are several types of **"Search Engines,"** and most are directories or databases of information broken into categories.

In order to use these sites, again you must be familiar with the terms and formats to help you access information. Search engines use their own special language to help you find answers. In Chapter 2 you read that even librarians use search engine *"speak."* Most search engines utilize what is known as either **Boolean logic** or **search engine math**. I will explain how to use each of these methods of searching the Internet in greater detail in Chapter 4.

Type of Equipment and Software Needed

Here's a quick review of some of the most widely used computer terminology for the types of equipment and software you will need within the fashion industry:
• Platform—MAC or PC.
• Cross-Platform—Can the files
 be opened on either platform?

- Operating System— WINDOWS or MAC OS.
- Software—Proprietary-industrial, commercial, off-the-shelf, third-party, or plug-in and application software.

In the fashion world it is not uncommon for some companies to be exclusively MAC or exclusively PC. However, a company may own and use both!

But don't get confused or let all this talk about different platforms and different systems affect you. Each of these computer systems has unique features and benefits, but as I just said, they also have a great deal in common.

In fact, the steps to designing on the computer are a lot like learning how to drive a car. Every car, no matter what the cost, has many similar features: an ignition, an accelerator, brakes, lights, and forward/reverse gears. You follow the same steps to start and move the car, irrespective of the car's price, make, or model.

Remember, *you* are driving the computer with basic skills, common design features, and the principles and fundamentals of design.

Design firms are no different. Many firms operate in what is called a cross-platform environment. They are also using multiple software programs to satisfy specific business needs. In other words, the designer can be using two different systems with multiple software programs to satisfy almost any business need.

When it comes to software, the Kodak website best describes the types of users today: "**Power User**—the pros are a small minority of imaging professionals . . . highly proficient . . . using high-powered systems."

The "**Unsold Masses**—those who merely view a computer as a tool for word processing and spreadsheets."

The "**Frazzled Few**—those who have attempted to become a power user, but have had an expensive and/or unsuccessful frustrating attempt with technology."

So, when it comes to the fashion professional, you must find yourself in the "power-user" category! If you are trained (or being trained) on one particular system, whether a MAC or a PC, as well as on one specific program (software), you already are developing the basic skills you will need to adapt to any other computer system or software. Here is snapshot of how these skills can be broken down by department.

The Design Department
The design team will generally use vector-based drawing programs and raster-based image programs to create a line. These software programs can be driven either on MAC or PC systems.

The Production Department
The production manager relies on database or spreadsheet-style software that will display vector drawing images of garments or details to maintain the accounting functions and production flow of a collection or line. These software programs also can be driven on either MAC or PC systems.

Sales and Marketing Department
The sales staff depends on presentation software that combines elements that are "camera-ready." They require software for making professional publications such as presentation boards, catalogs, or even web page design.

CAD *(Computer-Aided Design)*
Here's a brief background on CAD and how these powerful CAD systems control a paperless world in textile and garment manufacturing.

Computer-Aided Design (CAD) emerged in the 1970s. CAD originally dealt primarily with drafting and technical functions, with particular emphasis in the pattern making, grading, and maker making areas. Actually it was more an aid to manufacturing. Oftentimes you will hear the phrase CAM systems, which actually is the acronym for Computer-Aided Manufacturing. So, if someone asks you about your CAM training, you will know it is a term often used interchangeably with *CAD* and is commonly substituted for *CAD*.

Today, by incorporating graphic packages, designers can creatively conceptualize, create, and modify with the click of a button. A designer can change a collection

in so many ways without ever wasting paints, paper, or materials. Bottom line: the fewer the expenses, the lower the costs to the consumer.

Industrial Software—Proprietary versus Off-the-Shelf

Today's CAD software is available as either "industrial," also known as ***proprietary software***, or "commercial" software. The original CAD programs were designed only for specific hardware systems. These systems with their own CAD programs were sold directly to the textile and apparel industry. The advantage is that these programs, which can be called "turnkey" systems—they operate with one turn of the key—is that they were designed to create, produce, and operate the production end of designing. These systems are the luxury leaders of the industry.

Industrial software focuses on a specific industry and usually has a higher cost than the commercial software programs which are also categorized as "off-the shelf." ***Off-the-shelf software*** is generally less expensive software that is readily available to the general consumer.

There are other commercial software brands that can be further categorized as ***third-party.*** This means these programs such as Age Technology Plaid Maker Plus will work as a ***plug-in*** or ***add-on*** for software such as Adobe PhotoShop® and have design functions useful for fashion industry purposes.

Software Categories at a Glance

Drawing Programs—Typically these are known as vector-based drawing programs. Thanks to these types of programs fashion designers have almost traded in their paper, pencils, paints, and brushes for vector or drawing style software that creates freehand line drawings and object-oriented drawings. These programs have tools that add text, color, and patterns to a design. Some of the more popular drawing programs evaluated in this text are CorelDraw®, Adobe Illustrator®, and Macromedia® FreeHand.

Image Editing Programs—Raster-based programs generally edit realistic images such as photographs. These sophisticated programs are also known as paint programs. Paint programs have the added bonus of tools that give the illusion of images that were created with natural mediums such as chalk, pastels, and crayons that add unique effects to photographs or images. Some image-editing programs can also support drawing features. However, objects are represented as bitmap versus a vector image.

CAD Systems Software—CAD software enables designers such as those in engineering, interior design, architecture, or industrial to draft design. CAD for fashion typically falls under the first three listings as well as CAM for manufacturing-related directions for producing a line of clothing or accessories. This also includes costing, specs, and plug-in modules.

Desktop Publishing—Desktop publishing provides a complete package of features used in conjunction with page layout, graphic, and word processing options.

Spreadsheet Software—Spreadsheet software provides the business environment with programs that will perform everyday calculations typically used in business.

Word Processing—Used in all facets of business, word processing software is often sold in a suite or series package that includes a spreadsheet program.

Presentation Graphics Software—This type of software is generally used to create images in business environments, such as charts and graphs or images for slide show or spreadsheet-related presentations.

What Is a Download?
A **download,** as the name suggests, is a file in which you "bring down" text, images, or other data or even programs from another source to load.

Where to store the download
Before you begin to download you need to have a place to put the file you are downloading.
Suggestions include:
- Hard drives—
 internal or external
- Flash drives
- Thumb drives
- CDs
- Floppy disks
- ZIP drives

No matter where you put the file, I suggest you create a "folder" specifically labeled to

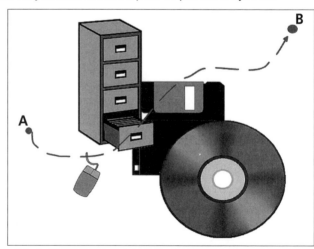

store the file, for easier access at a later date. Always remember to make backups of any critical data!

How much can you download and store?

The majority of the files you download from the Internet can vary from small to quite large. For the computer to receive the data efficiently and quickly, the larger files may need to be compressed. This means when you get ready to use the data, the file has to be decompressed. Decompressing a file will enable you to access and view the data.

The storage process is a lot like what you might go through when you are getting ready to take a trip on an airplane for a two-week vacation. Most airlines have baggage restrictions, but you have the "need" to bring a lot of extra clothes . . . so you begin to pack, unpack, and repack your entire wardrobe into an airline-acceptable-sized suitcase.

But like having the right-sized suitcase, you may find you need the right software or hardware to assist you in making these files fit properly.

How to decompress or "unzip" a file that you have downloaded

Some files can be easily unzipped and opened. Depending on your browser, the choice to decompress the file may be an automatic function that is accessed by clicking the OPEN FILE option from a pop-up menu on your screen. If the computer defaulted and saved the file in file format *.exe*, this means the file has been downloaded and saved in a self-extracting program. Go to the file where you saved the data and double-click on the *.exe* file. This will open the file. If, however, the file is not an *.exe* program or an extraction option is unavailable, you may need an extraction program to assist you.

The key to extracting your files is an unzip program such as WINZIP®. Several other programs are available that also can perform this task. You can log-on to *http://www.CNET.com* for a list.

Best file storage ideas

I suggest you be sure to always create a specific storage area for the files you download. Clearly name and label both the folder and the file according to its use and content—you will be glad you did!

Understanding Common File Formats

At this point I am going to give a brief explanation of some common file formats.

Choosing the file format for the image to be saved is an important issue. *File format* refers to the type of file the chosen design programs can read.

Most programs save a file automatically to its own default or own proprietary or native file format automatically. The challenge arises when the native file format is not always readable in another application or computer platform. So, how do you solve this problem? You need to give the file a special identifying extension after its name that will enable you to open the file, no matter what program or platform you use.

Now, if you save your file with a file extension that can be cross-platformed, in the long run you will save yourself a great deal of stress!

In the last section we discussed the importance of recognizing file extensions used in transferring a large portion of data online. I am including a quick reference chart for all the file formats you will need to recognize and understand when you are transferring—that is, sending and downloading—files online.

Chapter notes so far:

Common File Formats at a Glance
File Transfer Recap

Image/raster	Text/vector/code	Audio	Video	Compressed	Program	Vector image
JPEG or	Txt	WAV	AVI	ZIP	Com	.eps
.jpg						.ai
	Doc	MID	MOV	Lzh	Exe	.cdr
GIF or .gif	Wks	VOC	VOC	GH	Bat	
TIFF or .tif	PDF	AU	MPG	Z		
BMP	PS					
ART	RTF					
PIC	HTM					
PSD	HTML					
	ASCII					

File Formats in Detail

For Images
TIFF: Tag Image File Format
Characteristics include:
- Versatile
- Reliable
- Suppose bitmap including full-color
- Can contain multiple images
- Great for scanners, frame grabbers, and paint/image editing programs
- Transfer cross-platform

PICT: This picture format is native to a MAC
Characteristics include:
- Used with bitmap
- Object-oriented drawings
- Great for raster printers

EPS: Encapsulated PostScript
Characteristics include:
- Cross-platform: Mac and PC
- Great for high-resolution PostScript illustrations/vector images
- Files can be imported into other documents
- Can be scaled and cropped
- May not be editable beyond scale and crop
- Requires a PostScript printer for output
- Bitmap images may require tracing to convert images
- Vector images compress well in this format

BMP: A file format for bitmapped images
Characteristics include:
- Stored in Windows as a grid of dots or pixels
- Important for color information/color-coded as 1, 4, 8, 16, 24 bits, which means a 24-bit image can contain more than 16 million different colors

JPEG: Joint Photographic Experts Group
Characteristics include:
- Interchangeable format great for photos working with layers
- Each layer is independent of the others, which means each layer can be edited and individual layers can be preserved for additional editing

• Designed for compressing up to 1/20th of file's original size
• Designed to be used for full-color, gray-scale, and real-world images

*Several of the most popular **Native File Formats** are*
• Adobe PhotoShop = psd
• CorelDRAW® = cdr
• Adobe Illustrator = ai
• Corel Painter® = Rif

Common word processor file formats
• Microsoft Word = .doc
• Microsoft Works = .wks
• Universal word processor file format = Rich Text Format or .rtf or .txt
• Adobe Acrobat files are labeled as = .pdf

In Conclusion

With everything you have just read, you probably want to know when you should use the vector programs, and when you should use the raster. Understanding file formats is critical when transferring files. So, let's recap, asking yourself the following questions:

• What is the task I need to accomplish?

• What tools would I choose if I am doing this manually? Will my files be text, raster images, vector images, or presentation style?

• Who will ultimately view this work? The design team, production, marketing, management, or the consumer?

• Will the user of my file have the correct software necessary to open and view my files?

• Will the file open cross-platform? Or can I create a file on a PC and can the chosen file format open also on a MAC?

• What kind of output devices will be used for this work? Virtual-online web pages, hard copy, or for professional marketing materials completed by a service bureau or printer or in-house?

• What constraints must I consider? Budget and time? Will I spend too much time on an image that can be done for less time and money for in-house use?

Chapter Goodies
Hint—I have included the file format chart on the **Goodies CD>Open>The Internet-Common File Formats** *and also* **Geek-Speak Internet Terminology,** an alphabetical list of common terminology associated with computers.

Notes:

4. Internet and Search Engine Savvy
The Secrets to Mastering Information Fluency Online

Terms to look for:

Advanced search	Internet	Provider
Bookmarks	Keyword searching	Robots
Boolean logic	Links	Search engine math
Cookies	Listserv	Simple search
E-commerce	Metacrawler	Sorting your search
Email	Meta search engine	Subject headings
E-zines	Mouse tracks	Syntax
History	Natural language	Term weighting
Human ranking	Nesting	Textbox or text field box
Hyperlink	Newsgroups	URL
Hypertext	Operators	World Wide Web
Image search engine	Phrase search	

Search Engine Savvy—How to Conduct Online Research

In this chapter you will discover the secrets to better understand how to conduct online research including:

• What are search engines and how do I best use them?
• What are metacrawlers and spiders?
• What are subject directories and specialty databases?
• What are Boolean logic and search engine math, and how do I use them?
• Which are better, online or traditional library resources?

Now that you have become familiar with the Internet, it is time to learn how to conduct a successful search on the Internet as a fashion professional. Where to begin searching on the Web can be overwhelming. For the "newbie," researching online can be frustrating as well. Where and how do you begin to find such a specific piece of information in such a vast space? Trying to locate that elusive piece of information that will quantify what your instincts tell you can be daunting and often misleading. For many new to Internet research the information they locate usually is far too broad or of little value.

Let's face it, there may be dozens of sites on the Internet covering everything from suppliers for equipment to fabrics, but if you don't know how to find them by asking the right questions you are sunk! As stated earlier in this text, much of what the fashion professional needs is located in the area of the Internet known as the Deep Web. The nature of the Deep Web is so complex that I have devoted

the next chapter to explain it further. Thankfully much of what the fashion professional may need can be accomplished using one of the more popular search engines.

You will need to learn how to determine which is the best search engine for your specific needs as well as how to conduct an advanced search. Therefore it is critical that you understand how all search engines work, including their common features and searching capabilities as well as their limitations.

What Is a Search Engine? Going beyond Google™

The term "Googling" has entered the American lexicon of popular idioms and refers to researching the Internet using the popular search engine Google™. (See Figure 4-1.)

So, what exactly is a search engine and how does it work? A **search engine** is a collection of directories or databases of information that is broken down into categories. These huge databases of information can be compiled and sorted in a variety of ways, either by humans or by computers.

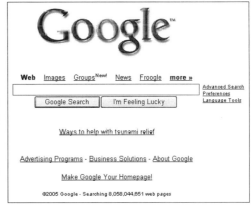

Figure 4-1

While there are several top search engines that lend themselves to the fashion industry, the secret isn't always which search engine you use as much as how you ask your questions or queries and what is the criteria used by the search engine for ranking results.

Popular Search Engines

Which are some of the top search engines used today? Here is a list of the top search engines beginning with the current favorite:

- Google™
- About
- Go.com
- Ask Jeeves
- AltaVista

Search Engines—How Do They Work?

Search engines in general are programs or **spiders** that roam, collect, and index information from the Internet. Much of the information gathered is Hypertext Markup Language (HTML) which is code driven. This means that the writer of the

code or the copy for the website can influence how readily a spider will locate the information. While it may on the surface appear that a search engine is the panacea for all your worries, it may not necessarily represent the complete body of information on the Internet. Asking the right question is essential to the researcher; unfortunately, the information gathered by the spider is only as good as the computer or software that evaluates it, not how accurately or precisely the query is posed. Furthermore, you may not know that your results depend on how good the copy or code writer is that influenced the spider or search engine.

The results recovered in the average query can reflect a high degree of noise or useless information that is unrelated to your query. To make matters worse, the information you gather may not be monitored or evaluated. Many results are fee-based or are based on fees paid for placement. Translation: You may or may not necessarily get the best results for your query; instead you might get a commercial for something that may or may not be what you are looking for.

Search Engine Categories

Upon closer examination search engines generally fall into several categories:
- Robot
- Crawler-based
- Indexing
- Pay-for-placement
- Internet directory
- Natural language
- Subject guides
- Specialty databases
 or even combinations of the above list

Did you know that search engines can be divided into further categories? Here is the breakdown:

Other Search Engine Categories
- Meta search engines
- Premier providers

- People and business
- Full-Web
- Directories and guides
- Newsgroups
- Specialty databases including
 - Next generation such as image-only databases
 - Internal databases (search engines within sites)
 - Fee-based or gated databases

When you finally get down to the business of research, it will be to your advantage to determine first what type of search engine you need and how the results are gathered and ranked. That is why you need to be familiar with the types of search engine categories there are available.

Meta Search Engines

The next important category of search engines is meta search engines. A *meta search engine* conducts the same query via numerous other search engines simultaneously. Several of the current leading meta search engines are *MetaCrawler, Inference, Dogpile, and MetaFind.*

On the surface this may sound like an answer to your prayer: Who would not want to work smarter instead of harder? The problem with using a meta search engine is that although it may seem efficient to conduct a search in several places at the same time, you will soon discover that the results are insufficient at best.

The **ranking results** (or the top list of responses to your query) are only a very small percentage of all the results available. To complicate matters, the top responses often may not be the best solutions that are available. As you review the list, the responses may be either too generalized or too specific. (See Figure 4-2.)

The good news is that later in this chapter you will learn how to refine your query in order to locate the best answers to your questions or the best solutions that fit your needs.

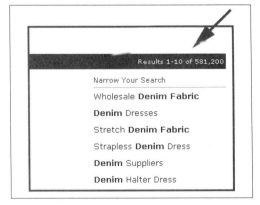

Figure 4-2

Subject Directories

As a researcher you also have access to what are known as **subject directories.** These databases are typically hand selected by editors for sites that have been organized in a hierarchical manner ranging from broad to narrow subject matter. On the plus side these sites have been selected, evaluated, reviewed, or ranked by an editor. On the downside the results on these sites may not be available in full text. Several examples of subject directories are *InfoMine* (a scholarly resource), *Britannica's Internet Guide, Yahoo!, Galax, LookSmart, eBlast, Argus Clearinghouse* and the *Librarian's Index.*

Subject Guides

In addition to subject directories there are **subject guides.** Subject guides are a collection of hypertext links on a given subject; these too have been compiled by experts on a specific subject matter. These experts may include serious mavens, companies, agencies, or nonexpert enthusiasts who excel or specialize in information on a particular hobby or genre. Examples might be *Argus Clearinghouse* or *WWWVirtual Library.*

Specialized Databases

As if that were not enough, the fashion researcher also has access to specialized databases. These databases are devoted to a specific task, topic, or subject matter. An example is *FirstView.*

People Searches

There are even search engines devoted to locating people. The URLs of some people search engines include:

http://www.bigyellow.com
http://www.switchboard.com
http://people.yahoo.com

Other Searching Solutions:
In the past, newsgroups have been a successful way for some researchers to obtain up-to-the-minute information. Several examples of this type of solution are:

http://www.liszt.com
http://www.deja.com
http://www.reference.com
http://www.telnet.com

Image Search Engines—Next Generation Search Engines

As noted earlier, until very recently most search engines are designed to search and locate HTML coded information; however, other pertinent information that might be indexed in traditional word document files or perhaps as a Portable

Document Format (.pdf) which represents Adobe Acrobat Reader file format. This could also include images that are in Bitmap File Format (.bmp) or Joint Photographic Experts Group Format (.jpeg) which are excluded from most searches. The good news is that several search engines are now designed to locate these types of file formats.

Understanding, Accessing, and Using Images Online

As a fashion professional you will need to consider other options while searching for information. Sometimes you will be called upon to find information you are personally unfamiliar with, or the text explanation is so technical that it almost feels like a foreign language. In such cases I suggest using search engines that have or specialize in image search capabilities. You will see just how image search engines work at the end of Chapter 8. This chapter focuses on practical how-to application exercises, including conducting an image search.

Here are several examples of image search engines:

• Google™
• AltaVista Photo Finder
• Arthur
• Yahoo!

The best examples can be found on Google™. (See Figure 4-3.) You can now request a specific image and Google™ and other search engines with similar capabilities can retrieve the image that most closely matches your query. The one striking feature about images located on the Web is that these images are only 72 dots per inch (dpi). This means the image has poor resolution. For screen resolution a low number is sufficient; however, for print, low resolution is of little value because the image will be grainy and pixilated.

Another consideration to image searches is the issue of copyright. Accessing images legally and of good quality for reproduction has become a major concern for the fashion professional. Because this is a hotly debated topic, it is well worth spending the time to clarify whether an image is in the public domain and is therefore copyright free and royalty free, or its copyright permission must be obtained.

Search Engine Secrets You Need to Know!

The key factor for any search engine is how the information is collected, ranked, reviewed, and retrieved. According to Danny Sullivan, the editor of *Search Engine Watch*, many major search engines get their results by turning to

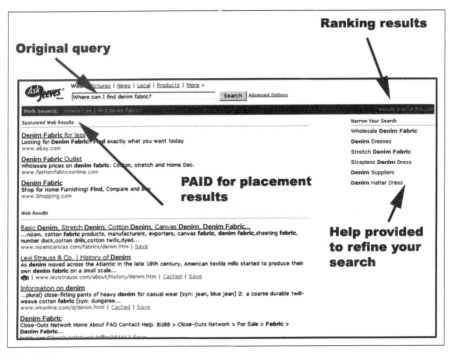

Figure 4-3

third party "search providers" to "power" their listings. Therefore, according to Sullivan, knowing who powers whom may be the key to determining the leading search provider.

Several examples of leading search engines are Google™, About, AltaVista, HotBot, Lycos, Excite, and Go.com. For an up-to-the-minute list I suggest you visit **http://www.searchenginewatch.com** for several excellent resource ideas on the latest in technology, trends, and other relevant search engine information.

Search Engine Recap
Let's examine more closely several of these categories to better help you understand what you may have been using online so far.
• Premier providers such as AltaVista, MSN, etc.
• Full Web search such as Excite, Northern Light, and Google™.
• Directories and guides such as Yahoo! and About.

- Newsgroups such as DejaNews.
- People and business such as Bigfoot, InfoSpace, and WorldPages.
- Specialty search engines such as Encarta, MapQuest, and Dictionary.
- Gated or fee-based—to quote a fashion-related website—WGSN-Edu.com.
- Internal search engines within sites, which also qualify as search engines.
- Meta search engines, which conduct multiple searches from many (meta) databases at once.
- Spiders or bots, where searches are conducted by a robot for keywords and phrases.
- Human search engines, or subject guides, such as About.com, which are so named because of the human input, ranking, or organizational factors.

Commandments of Good Business

Today, Google™ is becoming increasingly popular within the research community. One reason might be that It is easy to navigate. Another reason may be Google's™ philosophy or code of conduct. Google™ refers to these codes as "commandments."

Let's have a look at commandment #6, which states "You can make money without doing evil." Wow, to do no evil; what in the world is Google™ referring to? During an on-air interview for the television show *60 Minutes* on Sunday, January 2, 2005, one of Google's™ owners noted that the ranking results on Google™ are divided into two main columns. (See Figure 4-4.)

The column on the left is the ranking based on the query, while the column on the right indicates related paid advertising. Therefore, the client should be clear on how the choices are ranked. But do all search providers share this integrity? Sometimes, but not always. Some search engines may not rank the most accurate content highest, but instead rank by paid placement. Companies pay as much as five to fifty cents per click. The more elevated and enhanced the results, the better the opportunity for these companies to reach potential clients. This type of ranking needs to be posted clearly; in some cases it is not.

Google™ Me . . .

One of the many downsides of search engines is that they unwittingly fuel our appetite for the negative. Should there be any negative information about a company or even an individual online, the search engines cannot make a judgment call to determine the validity of the information. One great example of this phenomenon is from the *60 Minutes* television show interview of January 2,

Figure 4-4

2005. Leslie Stahl questioned the Google™ staff about the results of a query she conducted using Google™ to see what kinds of response the query would return. To her amazement, the only results that ranked highest on Google™ for *60 Minutes* were about negative interviews rather than facts about the show itself. (See Figure 4-5.)

Who Makes the Judgment Call for Accuracy?

In the interview, one of the Google™ cofounders lamented that even if some erroneous information about an individual or company has been published on the Web, most search engines do not have the ability to make a judgment call to determine which information to include in the results. He added that more likely

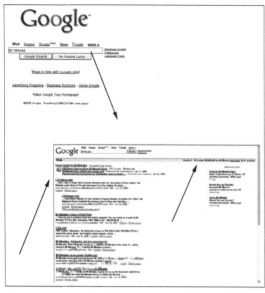

Figure 4-5

than not the negative informa-
tion will be included and typi-
cally will rank highest in the
results! Rectifying this is one of
the biggest challenges facing
the industry as a whole.

Another major concern for
search engine companies is
focusing on how to harness all
the information available
in any language and how to
translate it instantly for readers
on the other side of the globe.
At the Googleplex in Silicon
Valley, California, the team is
busy working on improving
what is one of the world's
largest search engines for the twenty-first century! It is hard to imagine that over
200 million times per day people almost anywhere in the world are accessing
data on Google™.

How Do Search Engines Work?

Everything Starts with a Question

When you use a search engine you will be asked to input
your request. Your request is known as a *query*. Be aware
that some search engines or queries are *case sensitive* (a
search in which capitalization of keywords must exactly
match the capitalization of words in the database). (See
Figure 4-6.)

Most search engines require you to ask them to search in
a particular fashion using what is known as groups of
words or phrases that relate to your query. This is known
as a *word string*. Search engines are either robots or
crawlers or are *human ranked*. (See Figure 4-7.)

Search Menu Commonalities

The Internet is about sharing information and it is reas-
suring to discover that there are several screen layout
commonalities that will enable you to sufficiently mine

Figure 4-6

Figure 4-7

Figure 4-8

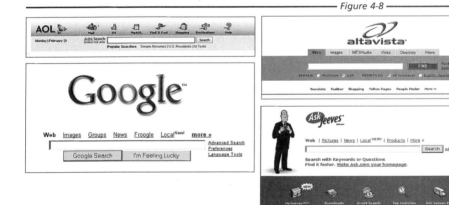

the Net for information. Regardless of whether you are visiting a corporate home page or using a search engine, all of them include basic navigational tools such as titles, menus, and status and scroll bars. Today most sites include universal icons, hypertext, hyperlinks, and multimedia functions. (See Figure 4-8.)

Regardless of the search engine you use, including the databases in your local library, the following items will be available: **keyword, subject,** and in the case of the library, **author, title,** and **number** (such as call numbers or publisher

numbers). In case of the Internet you can use the URL or HTML titles, and you will have the option to conduct your search by geographical location and even limit your search by language. Next, how the information is ranked or rated for relevancy is determined by the query conducted applying Boolean logic or search engine math.

Learning to Speak Librarian and Computer-Speak—Boolean Language
Or, It's Not What You Say, But _How_ You Say It!

Everything starts with logging on to the Internet and selecting a search engine and understanding the best way to you ask the right question to get the right answer.

Using the Internet and a search engine to obtain answers to your questions is easier than you think. It is much like a two-way conversation. In geek-speak, conducting a "query" is just another way of saying you wish to pose a question.

Much like human conversation, many factors can disrupt the flow of information. Just like you would take the time to find "another" way to convey your spoken message to another person, you may need to request your information in several different ways in order to get the desired results from a search engine. Therefore, take time to become familiar with exactly how a search engine interprets what you are asking it. This is accomplished using Boolean logic. This well-known librarian's tool can also be the key to your success using an online search engine.

Most search engines will require you to be familiar with their particular organizational structure for searching. Typically you will find that most databases utilize either Boolean logic or search engine math to locate a query.

In this next section we will delve into just how to begin your research using the most popular organizational structures of Boolean logic and search engine math. In order to do that you must first familiarize yourself with some of the pertinent jargon associated with conducting research.

Basic Types of Queries

The first and most basic query is a simple search. A *simple search* is when you pose a "simple" question to a given search engine or database. To begin research, professionals in any field will attempt to refine or narrow the results by beginning their request using what is known as a *keyword search.* A keyword search is locating a given piece of information you need by entering a keyword or

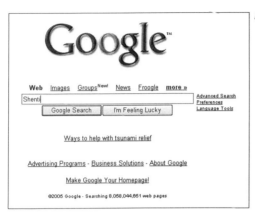

Figure 4-9

relevant term associated with your subject matter into the field box. A **textbox** or **text field box** is generally a small rectangular box located at the top of the screen with an ENTER or GO button situated to the right of the box. In these boxes is where you will type in your **query** (request). (See Figure 4-9.)

The **syntax,** or language you use to make your request, varies. We are not talking about asking in a specific language such as English or Spanish, although sometimes search engines do provide the user with that choice. Instead, **syntax** refers to the way you pose your question, whether it entails using natural language, keywords, key phrases, Boolean logic, or search engine math. (See Figure 4-10.)

Figure 4-10

How to Use Boolean Logic and Search Engine Math
The art and science for researching the Internet for answers
When it comes to mastering research you must become familiar with the most common methods of conducting research with a database including the traditional database of libraries or using a search engine online. Both Boolean logic and search engine math are where we start! **Boolean operators** are another way to assist in your quest. Boolean operators are words such as ***AND, OR,*** and ***NOT*** that can help you qualify your request to ensure results.

Using keywords with Boolean operators can greatly enhance your results. Another major contributing factor to successful research is being familiar with industry-specific terminology. Let's use fabric as an example: In the case of madras plaid I could use either the term *madras* or *plaid*.

Each of these terms will bring me back very different results. The term *plaid* may bring up several variations of plaids including the fabric known as Tartan plaid. While the term *madras* might lead me to a type of plaid fabric, it also could lead me to information about a geographical region.

Therefore, the more familiar I am with useful subject-related terminology the more specific and accurate my query results will be.

In the case of Boolean logic, here's an example to help you better understand:
1. If I type *Madras **AND** Plaid*, my results will be very broad and everything with the words *madras* and *plaid* will be displayed in my results.
2. If I add the word **OR** the results will be similar.
3. If I type *madras **NOT** Tartan* I am more likely to see results that are mostly associated with madras, thereby eliminating any unnecessary Tartan-related responses. As you can see, the use of Boolean operators can narrow my findings or actually broaden them.

Term weighting is a method to assist you in narrowing your query. Generally a higher number of synonyms for a given concept will carry more weight in the relevance ranking. This means entering more synonyms in your query will enable the search engine to clarify your query.

Another type of query is a ***phrase search***. A phrase search is when you opt to connect words that identify or clarify even more specifically what it is you are looking for. In order to narrow your search even further, type the request inside quotation marks.

There are other advanced functions you can use such as **nesting**. Nesting allows the user to set off a word or phrase with parentheses. Advanced phrase searches are further enhanced with the use of quotation marks, also known as proximity operators, within the nesting to further narrow or broaden the search. A great example might be "Tartan plaid." Using quotation marks ensures that the words are paired together and will eliminate all other kinds of plaids that will appear in the results.

Possibly the most beneficial search function to the fashion professional is the ability to rank a search by using features that will limit the results. This is especially useful when conducting trend research or other research that is time sensitive. If you are searching for the latest technology in digital textile printing, an article written and dated more than a year ago may be considered too old and may not have the most current information!

Keeping the other types of searches in mind, you may wish to opt for a **subject heading search**. While this may seem like a broader approach, the truth is that it may eliminate results that have the same "name" as your answer, but none of the relevance to your subject matter. In our earlier example of madras plaid fabric, madras may yield a fabric-related or a geographical result to your query.

Conversely there is another somewhat similar method known as **search engine math**. Search engine math uses symbols in place of word operators such as **double quote marks** (" "), the **plus sign** (+), the **minus sign** (-), **commas** (,), and **pipes** (|) to help broaden or narrow a search.

Sorting Your Search
What's next? Or many results—yet so few answers!
As you become more familiar with how to pose your query, soon you will discover that the best response may not come from your ability to narrow your search but from sorting your search results.

Timing Is Everything
Those who have used any of the Internet search engines may be amazed at the results you can get. In particular, you may have noticed that you have the ability to request a sorting of your results. "Ranking" can be in the form of either **relevance**, or **chronological** (i.e., by date or date order). Depending on the search you are conducting, both have very specific and appropriate uses for the fashion profession. For example, if you were conducting trend research, you can bet your first choice should be date order/ranking for when an article was written. You would not like to be looking at the latest spring trends in swimwear if the article

is dated May 1999! However, if you're searching for information that needs to be current and relevant, the date the data were written may not be as important as who authored the most relevant report! In other words, you would want *Vogue* magazine's current picks on swimwear trends, not some unknown website's opinion.

More Advanced Features
So far I have described simple or quick search methods. However, that will depend on the search engine you use. Many will have a plethora of other *advanced search features* available to use to refine and narrow your search. In some cases there is something known as *topic browse* categories to enable you to narrow your research. Topic and subject browse capabilities are the same thing. (See Figure 4-11.) These features will allow you to browse by topic while some databases will produce an *abstract*, or a brief summary of the data or topic; others provide *full-text* results.

Finally, look for the ability to set your number of records (a.k.a. citations) at a reasonable number. You do not want to sift through thousands or even hundreds of results. Most databases will permit you to do this as well as to annotate or even email or print your results.

Learning the *ins and outs* of syntax can really make a difference in finding that elusive answer. I have included a simple reference chart to using search engine math and Boolean logic.

Figure 4-11

Search Engine Math

Operator	Action	Example			
Capital letters	Indicate a proper name.	Ralph Lauren			
Comma (,)	Separates titles and names.	President, Bush			
Minus Sign (-)	Excludes a word or phrase.	Plaid-Tartan			
Pipe ()	Narrows a search even further if subject is broad.	Fabric	100% cotton	denim
Plus Sign (+)	Requires a word or phrase.	Karan+DKNY			
Quotation Marks (" ")	Signifies words MUST appear together.	"Christian Dior"			

Other possible combinations:

+Klein+Calvin–Anne	+Donna+Karan+DKNY	Check–Gingham–Houndstooth
Minus narrows request	+ adds to requirement	Several minuses focus request
	"Biography: Donna Karan"—colon with quotes narrows search.	"Check"–Gingham–"Houndstooth" Combos of quotes with minus sign significantly narrow search

Boolean Logic

Operator	Action	Example
AND	Includes both words used in search before and after the word *AND*. Any result that uses BOTH of the terms will appear in the response.	Donna AND Karan
OR	Includes both words used in search before and after the word *AND*. Any result that uses BOTH of the terms will appear in the response.	Donna OR Karan
NOT	Eliminates the term immediately following the word *NOT* in the results.	Donna NOT Karan

In summary, Boolean logic incorporates a logical inclusion or exclusion of words between words as well as the use of *logical search operators*. Utilize terms such as *AND, OR, NOT, AND ALL, OR ANY, NOT EXCLUDING*, and *NEAR* as well as the use of * wildcards to broaden or narrow your search on a given topic.

In the case of search engine math, it substitutes the uses of words (or operators) with symbols such as a plus sign (+), minus sign (-), and the use of quotation marks (" ") to conduct a similar search.

Information Fluency Tips
1. If search returns *too many results:*
 a. Add concepts.
 b. Always use phrase searches.
 c. Use jargon-specific words linking appropriate terms with *AND* and *NOT* to eliminate terms.
 d. Where possible, choose an option requiring *exact* term matches.
2. For *too few results*:
 a. Eliminate the least important concept or term to broaden your search.
 b. Alternate forms of spelling.
 c. Use more general vocabulary.
 d. Look for options to loosen up the concept match results.

Now let's have a visual look at the same concepts expressed in several Venn diagrams: The area in gray shows you how broad or how narrow your results will be depending on the operators you use. The first image shows the broadest response to a possible query while the last image shows you the narrowest response. (See Figure 4-12.)

Research Credibility—The Litmus Test
One of the biggest mistakes that can be made in doing research on the Internet is assuming that everything you find is accurate, reliable, and current. The solution is determining if the answer is reasonable and if you can replicate your response via another credible source. There is a biblical saying that a matter is settled "out of the mouth of two or more witnesses."

Take the time to attempt to replicate your finding from another source. Never assume the first response you find is "the" correct or, for that matter, "the only" response. Finding similar information from several credible sources goes a long way in enhancing your credibility in the industry.

Venn Diagram Chart for Searching

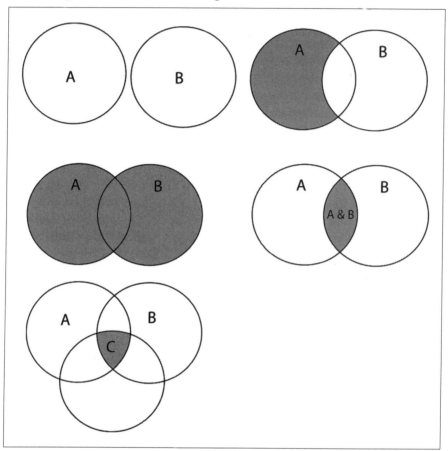

Figure 4-12

The following is a list of ways to ensure the information you find is credible.
• When you begin to search the Web, ask yourself some of the following questions:
 • What is the reputation or authority of the website? Its parent organization?
 • What is the purpose of the site?
 • How trustworthy is the site?
 • Who has created this website and provided this information? Who is responsible for the content? In what manner or language is the site written? Is it free from common spelling or grammatical errors? Is it relatively informative? Are there proper citations for the information you find?

- Is the information authentic, accurate, reliable, and relevant of value? Is it objective? Is it current? Is what you see what you get?
- Are these people considered experts in their field? Are they reliable and credible? Who are they accountable to for this information? For example, when looking for an article on the retail economy, are you searching *The Wall Street Journal* or the *National Enquirer*?
- Carefully contemplate where you are looking for answers! Attempt to verify the source whenever possible! Or, if you are looking for an authority in the field, be sure of the credentials of the author. There are numerous sites that have all the slick bells and whistles of a professional site, and you come to discover it was some fifth graders' project on the Renaissance.
- Ask questions and always verify your findings. Can you easily cross reference this material, making every attempt to verify your data? Often you will notice that if you have located the information and the extension of the site ends with a .edu (educational site) or a .org (an organization) you may find that information pertaining to your specific subject matter may be much more reliable than information found on a .com. This does not negate the information found on a .com site; however, if you are unfamiliar with the subject matter it is better to have two or three sites all giving the same information. Multiple sites need to agree and have the same information. In fact, two or three sites that are educational websites or trade organization sites may have more relevant or accurate information than a .com site.
- Don't assume that the Web is the one and only source—the Web doesn't replace all traditional sources. It has its drawbacks too—great photos never replace the touch of a fabric. So verify everything including colors, sizes, the content materials, quality of construction—*everything!*
- Who else links to this site? Always check out the links from credible sites to see what other URLs they recommend.
- Determine if the links in and out of the site work.
- Don't forget, websites need updating, so be sure your information is current. And oh, yes, like anything else, sources found on the Web can be here today and gone tomorrow, so have several comparable back-up sources; you might just need them!

Remember, anyone can publish a website. You must evaluate the content of the sites you visit and be prepared to take responsibility for the information you have gleaned. While the information is vast in scope and sometimes difficult to refine, for a fashion professional like you the Internet can be a rewarding and useful tool!

Mouse Tracks
When to keep a record of your tracks and when to cover them!
Finally, you will want to consider how to keep track of the websites you have visited while conducting your research.

There are several obvious reasons you will want to remember how to get back to a given site. Bookmarks let you permanently archive the sites you visit. (See Figure 4-13.)

For starters, most browsers have the capability to organize these URL bookmarks according to your needs, such as subject matter. (See Figure 4-14.)

The bookmarks are typically stored in a folder on your hard drive. This is terrific if you are *always* at the same computer, but what if you need to work at a different computer than where your bookmarks are stored? This can be problematic, which is why you may wish to consider subscribing to a service that stores your favorites or bookmarks for you.

Today there are several simple solutions to remembering specific URLs. Naturally, you can take the time to jot them down in a notebook or day-timer. If you

Figure 4-13

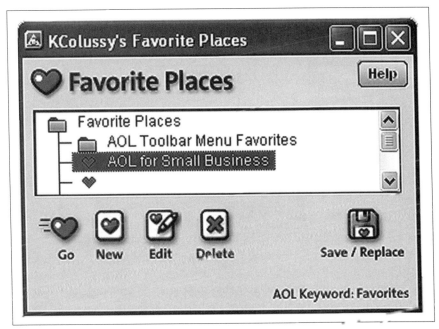

Figure 4-14

prefer you can subscribe to one of the many online services that provide bookmarks and storage for all of your favorites. Often these services grant you access with permission to other subscribers' record of favorites who share similar interests.

Are You Being Followed?

Good Cookie . . . Bad Cookie

For those of you on a perpetual diet, relax—we are not talking about carbs or sugar, we are discussing an item that is widely used to track a client psychographic known as a *cookie*. Cookies are coded pieces of information that are deposited knowingly or unknowingly on a computer when a site has been visited. Cookies are able to track the users' pattern of buying or Internet usage, which in turn provides specific marketing information to the host site.

Figure 4-15

There are good cookies, used by reputable companies to enhance your online experience such as your favorite retailer. Perhaps you have noticed when you log-on to your favorite online bookstore, you are greeted with "Hello [Your Name Here], welcome back . . . here are a few shopping recommendations for you today." (See Figure 4-15.)

Although this can be a blessing, many other types of cookies in the form of "spyware" can seem more like a curse. These can be in the form of nasty little pop-ups that hijack you to their site without your consent. Worse yet, they can infiltrate your hard drive and retrieve your data for unscrupulous unauthorized users to track your Internet usage or, worse yet, steal your personal information. Today you must arm your computer not only against unsuspecting viruses but also against spyware!

Search Engine Tour du Jour

As we conclude this chapter on search engine savvy it is time to introduce you to several of the leading giants in the field today. I will begin by introducing you to their features and benefits along with a profile of what you can expect from using these sites.

Have a look . . .

Go to your CD and open the folder entitled > Chapter 4 > SEARCH ENGINES CHART.

Now it's your turn!
OK, get ready . . .
I suggest you visit each of these search engine sites and notice how they are structured. Check out the search engine home page; what options do you really have? Glance around the site and see what kinds of parameters the search engine may offer. Look for the pros and cons of the site structure and determine how easy it is for you to use. Ask yourself what other features are available and which of these advanced features best serve your researching needs.

I suggest you log-on to the Internet and go back and visit these sites and jot down your notes and observations. Ask yourself the following questions:
- Am I comfortable with the interface?
- How does this site work? Does it use Boolean logic, search engine math, or natural language?
- Does it have advanced search engine capabilities?
- Does it have a tutorial?
- How user-friendly is the site?
- Can I conduct an image search?

Basic How-to Steps
Search Engine Research Savvy
- Go to the search engine of your choice—for example, **http://www.go.com**.
- Look for the language you are most comfortable speaking to do your research (e.g., English).
- Type your request as concisely as possible (e.g., *Wholesale denim fabric*).
- Experiment how to narrow your research by using word strings.
- Be sure you spell everything correctly and use appropriate capitalization for proper nouns.
- If you find that the responses you get are too vague, continue to narrow your search using *similar words, multiple words, commas, quotation marks*, and/or *plus signs* to separate the words. Another frequently used **operator** is the *minus sign* to indicate a degree of less importance. Avoid leaving spaces between the operator and the search term.
- Now, go to another search engine—I suggest **http://www.google.com**, and compare results. Sometimes the same questions posed at another search engine elicit very different responses.

Jot down your thoughts and observations here:

Finding data via the Internet gives designers and fashion professionals an "instant library" right in their own offices. It is as easy as clicking the mouse. Remembering the basics we covered in this chapter will go a long way in helping you become a successful researcher.

Search Engine Snapshot

In this section you will find a brief overview of several leading search engines.

ABOUT has several terrific subject guides including one that specializes in fashion. (See Figure 4-16.)

ASK.com, at **http://www.ask.com**, begins by soliciting you to pose your question

Figure 4-16

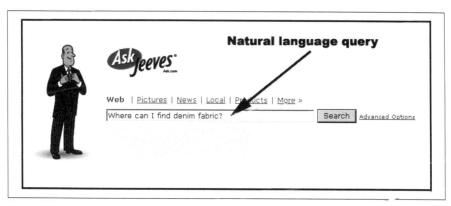

Figure 4-17

in a natural language. *Natural language* is typical everyday conversational style, such as *"Where can I find denim fabric?"* (See Figure 4-17.)

As you visit other search engines it is important to remember that most search engines are case sensitive. You may also notice that the search engine may require you to use capital letters for proper names. In addition, it is important to remember that other search engines will work better if you utilize **word strings**. As described earlier in this chapter, a word string is a combination of words or a phrase that focuses to help narrow or broaden a search. (See Figure 4-18.)

AltaVista

Another special feature of a search engine may be that it has the capability to conduct your search in several **different foreign languages**—what a blessing this is, especially if your native language is not English. Let's imagine using the English word *dress* when what you meant in Spanish was *traje*, or perhaps *bestidude noche,* and not *bestido de gala. For those of you who speak Spanish there is a big difference, right?* For English-speaking readers, allow me to explain how similar the following fashion terms are: after-five, evening gown, and night gown.

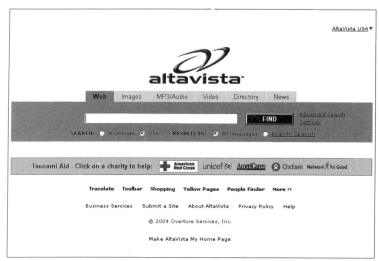

Figure 4-18

You may recognize the commonalities and the subtle nuances that each of these terms may have. But imagine saying "evening gown" and instead the other person hears "night gown"! (See Figure 4-19.)

You can see from this example that it will not take long for you to recognize the advantage to understanding how to pose a query in a search engine—especially if you or your client do not use English as a primary language. For speakers of other languages researching in English can be a stumbling block, even when attempting to use the simplest words.

Hint: You will perhaps want to use a search engine that utilizes several language capabilities, including your native language. Begin conducting your search first in your native language, then double-check your response by posing the same question again in English.

Figure 4-19

Figure 4-20

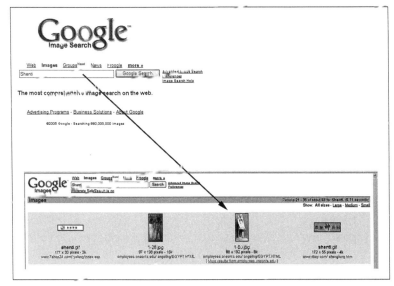

Figure 4-21

More Googling!

Google™ is a real favorite for fashion professionals because it has image-driven capabilities. (See Figure 4-20.)

The search engine is fantastic for the fashion researcher who is searching for historical costume information. Remember that old adage "a picture Is worth a thousand words"—nothing could be more accurate when using Google's image-driven search engine. For example, perhaps you need information in regard to the type of clothing worn by the ancient Egyptians. Begin by using one or more key terms used to describe an article of clothing, and enter one of the keywords such as "shenti" into the field dialog box and *Voila!* (See Figure 4-21.) Your results will be a listing of images that represent the word.

Notes:

While you may also notice several images that do not represent your query (noise), the majority of results that are ranked will frequently lead you to reliable, authoritative sites such as universities, museums, or costume organizations.

Let's Review . . .
Avoiding GIGO—or how to ask the right question!
In order to use any of these sites you must be familiar with the terms and formats most search engines use to help you access the information. Here, more than ever, *"GIGO"* (garbage in, garbage out) is what you will get if you are not paying attention.

Spelling does count!
How you pose your question will be the focus of this next section. Let's start with the basics: spelling.

I cannot stress enough the significance of using the correct spelling when asking a question online. Let's face it, for many fashion professionals or students spelling is not our forté. So, when in doubt use a dictionary or don't be afraid to ask someone how something may be spelled before you begin your search.

Recap for how to conduct an online search . . .
• Identify the key concepts you wish to locate, then break down your topic into concepts.
• Read or review directions for using the search engine before beginning your query.
• Look for keywords that are concept related and utilize industry-specific concepts wherever possible.
• Some search engines do not need caps, but all search engines need you to spell the words correctly! When in doubt use a spell check or a dictionary!
• Always query in Boolean logic using weighted terms and phrase searchers, along with limiters such as *AND, OR*, and *NOT*, truncation, and nesting.
• Type in your query and click the Start Search, Submit, or Go button.
• Try repeating the search in various alternative words and phrases.
• Wherever possible, do an image search with industry-specific terms.
• Don't be afraid to try a different search engine.
• If the search returns *too many results*:
 • Add concepts.
 • Use phrase searches.

- Use jargon-specific words linking appropriate terms with *AND* and *NOT* to eliminate terms.
- Where possible, choose an option requiring *exact* term matches.
- For *too few results:*
 - Eliminate the least important concept or term to broaden your search.
 - Try alternate forms of spelling.
 - Use more general vocabulary.
 - Look for options to loosen up the concept match results.

Final Observations on Resourcing and Researching on the Internet

Believe it or not, I could fill a book on fashion-related websites.
But here are just a few more tips you may wish to remember:

- Always make a bookmark or mark your favorites for easy access.
- The Web is very organic—always changing and never static. Be sure to archive and save data you cannot live without; you will be surprised how many times you will go back to a site to discover that the information is no longer available.
- Don't panic when you can't go to your site; consider that sometimes the sites are "busy" or "down" for maintenance or updating. (Night owls in particular will discover this to be true.)
- When searching for information always ask the same question several different ways.
- If English is your second language, try conducting your search in your native language first.
- Don't believe everything you read on the Web. (Remember GIGO, not to mention "buyer beware.")
- If an unwanted pop-up window appears, do not hit the Close button; instead hit the "X" to close the box and always—always—be sure you keep your virus and spyware protection updated!
- Pay attention to how you pose your query. (When I went searching for specific costume period sites such as the Gothic period, I found an amazing amount of unrelated information that had little to do with my subject matter. Choose your word strings carefully!)
- Remember, like anything else computer-related this is just a tool. Use several sources for your research.
- Don't forget to use trade publications and journals to see how a company may be abbreviating its name.
- Take the time to evaluate most of the major search engines to determine the one that suits your needs and is easiest for you to navigate.

The secret is to recognize what the strengths and weaknesses of a given search engine may be. In general, search engines will have the following characteristics:

• Simple search capabilities
• Advanced search capabilities
• Search by language
• Search by geographical location
• Search within a time or date range

Search engines will typically search approximately 90 percent of the Web. However, the way you request this information can vary your results from a small number of quality responses to a large number of inaccurate responses. Targeting the right information is like choosing to use a rifle or a Magnum! One is very focused and precise, while the other covers a wide area that may or may not be the target.

Hint: Practice what you already know! Taking time to practice using a search engine tutorial is most beneficial. I suggest you practice with simple subjects that

Figure 4-22

you are extremely familiar with and evaluate what the correct responses should be. No matter how insignificant the topic may be, practicing on a subject you are most comfortable with is an excellent way to master Boolean logic. For example, if your hobby is a particular sport or if you are the movie trivia maven, why not begin to practice the art and science of research with subjects you know the answers to. The goal for acquiring these skills should be to progress from good to better and then to best.

Finally, those who are learning to use Google should note that it has several features that come in handy for shopping—a section entitled **Froogle.** You can even narrow your search to your locale or part of the country. For example, if you live in Miami, Florida, you can type in your zip code and Froogle will limit its search to that area. (See Figure 4-22.)

Summary
In no time at all you will be using Internet and librarian-speak and sourcing your way to solutions and secrets you never dreamed were possible. Your answers are only a few keystrokes away!

To avoid alienating any of the readers who are still new to the process of searching online, I have included a complete search engine glossary you can access located on the Goodies CD: Go to the **Goodies CD> Chapter 4 > Search Engine Checklist AND Chapter 4: Search Engine Savvy and Internet "Geek-Speak" Glossary.**

Notes:

5. Myths and Marvels of the Deep Web

Terms to look for:
Blog
Boutique search engine
Deep Web
Presourcing
Resourcing
Surface Web

"Presourcing the Net" for facts, stats, and trends
So what kinds of information will you expect to be searching for?
In Chapter 1 you learned that sourcing is locating the right materials, information, manufacturing facilities, or equipment from the right source at the right time and at the right price *(and hopefully with the least amount of angst!)*.

Sometimes the information you will need to research can include statistics and other quantifiable facts. This and other similar types of information will then be analyzed in order to identify the direction and trends the industry is adopting. I call this information ***presourcing***. The information you'll find will include everything from consumer demographics and psychographics to color and trend forecasting. Armed with this information, product development, design-related buying or purchasing, as well as other major decisions can be made with confidence.

Resourcing versus Presourcing
Let's review the difference in the kinds of things you will be researching. Presourcing will involve finding facts or *information* that quantify, verify, and validate the decision to be made, whereas traditional e-sourcing might involve locating valuable tangible items such as fabric, findings, machinery, technology, and facilities.

Remember, all facets of the fashion industry, including garment or textile design, production, and sales and marketing, involve sourcing. It does not matter if you are operating as an independent designer for your own label, designing in-house, or freelancing for a leading designer, everyone—including the major manufacturer or product developer for a leading retailer—sources!

The questions are: Where is the best place to start, and how can I best use the Internet to facilitate this task? Much of the information you will need may be found in an area of the Internet known as the Deep Web.

Surface Web versus the Deep Web

Finding specific information on consumers' buying habits or even on the latest trade laws is not for the casual Internet user. In fact, finding this type of information is one of the biggest challenges facing any research professional. The information most people glean from the Internet comes from what is referred to as the *surface Web*. The **Deep Web**, also referred to as the *invisible* or *hidden Web*, is comprised of industry-specific information and is more like an anomaly or a mystery, especially to someone learning how to use the Internet as an online research professional, and may or may not be gated.

I have found that, surprisingly, a greater portion of the Internet's Deep Web is where all of the best fashion-related information is located! So the question really is, *Where and how do I find it?*

First the good news . . .

One of the biggest myths surrounding the Deep Web is that it is inaccessible. This is simply not true. What you need are the keys to mine this portion of the Web. The purpose of this chapter is to introduce to you, as well as reveal to you, the secrets of how an industry professional can access and then apply this valuable information.

Now the not-so-good news . .

Looking for relevant and useful information on the Internet is much like diving in the ocean for buried treasure. *The information is out there*—but where do you begin in such a vast location? Sometimes you just have to know where to look. So, first let's begin to clearly define what the Deep Web really is.

Deep-Net Fishing or Mining the Hidden Web

The majority of the Web that is indexed by the average search engines is referred to as the surface Web. According to Dr. Jill Ellsworth who first coined the phrase *"Invisible Web,"* or Deep Web, this area of the Internet known as the Deep Web is not easily accessible by most search engines.

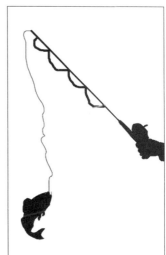

The statistics are staggering for how big the Deep Web really is. According to Michael K. Bergman of Michigan State University, the Invisible Web is approximately "500 times greater than

conventional search engines. The Deep Web contains 7,500 terabytes of information to the nineteen terabytes of the surface Web."

Allow me put that into lay terms—*whew! That is a lot!*

In today's paradigm of differentiating the Deep Web from the surface web, it has been said that what cannot be seen cannot be defined, and what cannot be defined cannot be understood. For the majority of today's search engines this is a truism when trying to chart or, in this case, index the Deep Web. However, according to the more popular traditional search engines such as Google this is beginning to change. As technology continues to evolve, knowledge will begin to increase exponentially. In the ancient Hebrew writings this was clearly predicted in a passage from the book of Daniel (Chapter 12:4): "Daniel, shut up the words, and seal the book, even to the time of the end. Many shall run to and fro, and knowledge shall be increased." Nothing could be truer than the advent of the Internet. The amount of information that becomes available each and every day on the Internet is overwhelming!

Key—For the professional fashion resourcing and researching expert, the truth is *you will not only need knowledge for how to gather this information, but wisdom and insight on how to translate, analyze, and transmute this information into products and services that serve your ultimate client's needs.* For the designer this means designing is not about divining trends but quantifying, analyzing, and applying them to best reflect the company you are working for and your ultimate consumer.

Understanding the reasons why you must learn to research and how to research is sometimes the least favorite thing a young designer wants to do. This is especially true for the individual who possesses a great instinctive sense of what is and will be hot and what won't sell at all. The truth is, today's companies do not have the funds to gamble if your instincts or perceptions are wrong. You must quantify, with hard work, data that was mined either through traditional or nontraditional means. Hopefully that will validate what your instincts are telling you about the next big trend waiting to happen. You need to comprehend the differences between the surface and the Deep Web and learn where to begin your search to validate what your instincts are telling you!

Surface Web versus the Deep Web

Let's compare and contrast the differences between the surface Web and the Deep Web.

Surface Web	Deep Web
Board content	Board, yet with specific content
Ranking by relevancy	Ranking by relevancy
Ranking can be purchased	Non-HTML files
Quality relevance subjective	Great quality relevance
	Content uniquely valuable
	Growing exponentially to surface Web
	Sites are typically private or internal
	Approximately 500 times greater than the surface Web in size and information

Indexing the Surface Web versus the Deep Web

Unfortunately the tools to uncover the hidden Web are limited for general access. The reasons are fairly simple to someone who understands the complexity of how traditional search engines work. If you recall in our last chapter we noted that traditional search engines gather information in a very specific way that is HTML code. When it comes to reviewing and indexing data from the Deep Web they are impaired and cannot locate these pages for one or more of the following reasons:

- Most Deep Web pages are not just HTML. In fact, they have been written in a variety of different formats that go undetected by a spider, bot, or metacrawler.
- The Deep Web can consist of sites that are gated, requiring log-in or registrations.
- Deep Web can include archives of full-text articles.
- Both the Deep Web and the surface Web are image intensive. However, locating Deep Web images and corresponding data can be problematic for most traditional search engines.
- Deep Web can be dynamically-created web pages including interactive websites.
- Deep Web pages can be considered organic, meaning that the content is not static, while in the surface Web, many URLs are dated and may not reflect current information.
- The fact is that it takes time for bots to search out new information online and report back their findings. Frequently this can take up to several weeks! Many sites in the Deep Web are typically much more time-sensitive and current.

- Websites that have the word "copyright" within the titles or within the body of text can also go undetected by traditional bots, which have been programmed to overlook or disregard those sites.
- Another form of barrier to traditional search engines are firewalls or other gates that have been posted to keep out software bots.
- Most intranets are often inaccessible to either the surface or the Deep Web.
- Deep Web pages typically are in the following formats:
 - Flash.
 - PDF.
 - PowerPoint.
 - Shockwave.
 - Written in programs such as WordPerfect or Microsoft Word.
 - Pages that are very image-intensive are also problematic for most search engines with the exception of Google and AltaVista, which have been scripted or structured to content with image-specific queries.
 - Another problem can be script-based pages or even links that contain a "?" *Why?* Most search engines are instructed to avoid pages with a question mark. Translation: You may or may not be able to access this portion of the Web with traditional search engines.
 - Finally, most search engine spiders cannot bypass gated sites that require a simple log-in or password. For researchers like yourself, this means that spiders are thereby foregoing and missing a large percentage of vital or sensitive data because their inability to index has been halted by a gatekeeper—specifically a password. It has been determined that sometimes, depending on the savvy of the web developer, the Deep Web query has been able to bypass less sophisticated gatekeepers.

Deep Web Marvels

Now for the great news . . .

The fact is more than half the Deep Web is topic-specific and almost 95 percent of that is publicly accessible! That is great news for researchers who have the savvy to access this kind of data.

This section of the Web is also the fastest growing. In fact, most libraries have placed their catalogs online. It should be noted that there is a similar trend to post quality data online for review that has been fueled by major corporations as well! According to Michael K. Bergman of the University of Michigan, in his white paper from July 2001 entitled *The Deep Web: Surfacing Hidden Value*, which was reprinted at *http://www.Brightpanet.com/technology/deepWeb.asp*, the Deep Web provides us with some very insightful and interesting facts.

Bergman states, "The Deep Web has more than 200,000 sites in existence, and just 60 of the Deep Web sites receive 50% greater relevancy than surface sites."

Bergman goes on to cite that "the total quality of the Deep Web is 1,000 to 2,000 times that of the surface Web and is 500 times larger than the surface web. However, the invisible portion of the web will continue to grow exponentially before the tools to uncover the hidden web are ready for general use."

Boutique Search Engines?

An article entitled Mining the Deep Web with Specialized Drill by Lisa Guernsey for BrightPlanet.com describes a new type of search engine coming to the forefront of the Deep Web known as boutique search engines.

Boutique search engines are frequently designed as topic- or industry-specific software agents or bots that are created to locate information that goes undetected by the other more traditional search engines. They are devoted to areas of specialization such as medicine, news, law, business, finance, fashion, and even for shopping bodies of information.

Hearing Is Believing

Recently, hearing is believing for those who desire to use their ears to listen online. You can choose to visit the Scottish-based website *http://www.speegle. co.uk*, which offers synthesized-speech renditions of articles from nearly two dozen news organizations, including the BBC, Reuters, and *The New York Times*.

Many of these sites house enormous quantities of data and get thousands of hits per month, but are generally unknown by most people. Their primary mode of advertising is often by word of mouth. In fact, here is a sampling of just a few of these sites that may be useful to the fashion professional:

• MYSimon.com—a shopping bot that is designed to scour the Internet and compare prices, usually retail items in almost any category
• FindLaw.com—obviously specializes in relevant legal topics
• FinancialFind.com—provides timely financial data
• Moreover.com—specializes in the most current global headlines and news items
• TechExchange.com—fashion industry and technology driven

The list keeps growing. Remember, the surface Web has access to as little as 1 percent of all the data that are available online. Lisa Guernsey for BrightPlanet.com

goes on to note that "As many as 500 billion pieces of content are hidden from view." However, technology today is moving toward overcoming these challenges and in many cases a skilled researcher is very successful.

Your key to success is practice, networking, and constant curiosity—always asking questions and always thinking outside the box when asking those questions online!

In conclusion, the serious information seeker can no longer disregard the significance of the Deep Web; the goal is to successfully access and harness this valuable resource. While the surface Web is most popular for the masses, *you* need to begin to access the hidden Web.

Use many of the secrets of researching, including ranking, relevancy, quality, and accuracy, which are of vital importance to the research professional. Let's take a moment to think about what kind of information you will be looking for and where it might be found.

Taking Traditional Research to the Next Level Online

In Chapter 2 we discussed research information that in the past was obtained within the walls of a traditional library. Today, many of the venues are websites. While much of the information may be gated, it is still easily accessed from your computer online. A recap of what you learned earlier in Chapter 2 is presented in the following table.

What	Where
Economic overview	*Standard and Poor's Trends and Projection*
Consumer spending	Consumer buying guide
Statistics, tax, tariff, and trade information	U.S. government resources, daily and trade newspapers, consulting services, ITC (International Trade Commission), International Trade Association, Big Emerging Markets (BEMs)
Trend information	Trade shows, trade publications, consulting services, and leading trade councils and associations and reports
Buying offices Product lines	Sheldon's company directories and Ward's index guide to top 500 companies, Hoover's
List of small and large manufacturers	Thomas Registry

Remember, the good news is that much of this information is now available at your fingertips!

Finally, I have included several simple techniques to help you mine the hidden Web for fashion information below.

Specific Secrets to Accessing the Deep Web

- Use the correct verbiage, the right phrase, and the specific vocabulary to unlock the Deep Web.
- Practice and master conducting advanced search methods using traditional search engines—a time investment well spent!
- Experiment with image-based queries such as Google.
- Be prepared not to always find the most current information on topics unless you have located a boutique search engine that specializes in being up to date in a given topic or subject matter.
- Once you begin to locate major industry-related sites, spend the time and energy to follow their links. Remember to save any relevant data you find— sites are organic and you may not find it the next time you visit the site.
- Use well-known trade-sponsored sites to access data—specifically trade organization sites.
- Seek out help—networks, libraries, and other valuable sources should not be discounted.
- Be sure to inquire if there are trial offers for premium providers to determine if they will serve your purpose. Free trial periods may be available for you—so why not just ask!
- When searching for white papers, try to use the names of key individuals known for their expertise in a given area. Often this will lead you to postings of their research and may even produce copies available to download.

Where to Go When You *Still* Don't Know Where to Go

Still having difficulties locating all the exact information you need? Relax, don't panic. There are other places you can search when all else fails After researching via traditional sources, Internet industry professionals turn to the following resources for help. These are just a few ideas . . . many of which are useful to students learning how to research and a great reminder for those already employed within the industry.

Several of the most popular traditional sources are the easiest to access:
- The local library.
- Company archives—it may mean looking to the past to discover what has worked and why, and what did not and why? Ask questions.

- Other trade website sponsors—always look at who else is a sponsor; check out the back-door links, too.
- Networking sources—be sure to take advantage and utilize industry contacts.
- Referrals from other industry professionals.
- Conventions.
- Trade shows and trade journals—typically trade shows or once-a-year trade organizations publish or index their membership and other affiliations.

Trade Organizations

The benefit of belonging to a trade organization and the luxury of attending trade shows or a seminar cannot be overestimated. Who can count the true value of seeing an actual demonstration of, for instance, proprietary software versus *merely reading* about it online or in a brochure—or the networking potentials that can result in increased sales or finding new vendors? The benefit of speaking face to face with someone and asking questions is immeasurable.

Possibly one of the most underrated and overlooked methods for finding the best place to begin is asking someone within the industry itself. It never ceases to amaze me why our human nature prevents us from asking for help. I can say from personal experience my biggest regret in my early years of freelancing was that I confused stubbornness with persistence.

Blogs and Other Trends in Online Information

For those of you seeking the ultimate in Deep Web marvels, there is still one last mountain to scale, the world of blogs. So, what in the world are blogs and bloggers, and what is blogging? **Blog** is slang for **Web log**. A blog is a web page that serves as a publicly accessible personal journal for an individual. Blogs are basically an automated way of sharing information related to search engines, listservs, message boards, and instant messaging. Typically updated daily, blogs often reflect the personality of the author and pertain to a specific subject or topic. By streamlining or simplifying the web page creation process, blogs have enabled users to easily transform information into a stream of constantly updated information.

These sites can be of much help to the fashion professional looking for information from individuals or groups that specialize in very specific banks of information that are relevant and current to all things fashion.

Bloggers, individuals who post journals and opinions online, can streamline information overload on subjects ranging from industry trends to marketing strategies and more.

Mini Glossary

Blog or Weblog or Web log

This can be a website where the author, or "blogger," periodically posts news, personal thoughts, links, or picture/audio/video files to which visitors to the site usually can comment or respond.

Directory

Here, a directory is a list of blogs, often arranged alphabetically.

Search Engine

This can be a feature on search engine websites where a user enters a keyword into a text or field box for the computer program to execute a search within that website for occurrences of that keyword.

For the reader wishing to know more about blogs, bloggers, and blogging, try visiting *http://www.blogmechanics.com/bob/* or *http://www.ipl.org/div/blogs/* for more information. For those looking for a fashion-specific blog, try logging-on to *http://aapnetwork.blogspot.com*, Online Expert Advise sites for a fee and for free. (See Figure 5-1.)

If you are still struggling, why not consider accessing some fee-based services that specialize in information fluency? If "time really is money," you will see many larger corporations budget for other companies that specialize in trend research to do the work for them.

This is often more cost-effective than having an in-house team of employees who are devoted to the task of research.

Figure 5-1

But what if you don't have access to these types of pricey services, where else can you turn? If all else fails, remember to try to locate subject guides online—many of these services are free, while several are fee-based. Either way, most have email links to write to the human subject guide and pose your query directly to them. You might be surprised when they respond to your query. Besides, you have nothing to lose by writing! The only "dumb question" is the question you don't ask!

On the GOODIES CD is a list of sites that may be beneficial to you as well as links to articles on the Deep Web. Go to **Goodies CD> Chapter 5> DEEP WEB LINKS and FREE and FEE-Based URLs.**

In our next chapter, we will interview an industry expert from one of the leading industry databases. So, let's move on to hear from some experts who will reveal more secrets and marvels to mining the Web and Deep Web!

Notes:

6. Interviews with Industry Insiders

In this chapter you will be introduced to several strategic industry resources you will want to be very familiar with. It will also include interviews with leading research and sourcing experts. They will share with you their strategies and secrets to conducting successful research. Featured company profiles and interviews include:
- *Cotton Incorporated*
- *Graphics of the Americas Trade Show*
- *[TC]² and Techexchange.com*
- *Pointcarré USA*

Also covered in this chapter are two insightful articles that discuss:
- How to go on a research buying trip to Europe
- How to attend a trade show
- How to pack for business travel

One benefit from interviewing or talking with industry insiders is that of gaining insight from their experience and expertise. Many people approach the subject of research from different perspectives.

There appear to be two main styles of approaching research: zeroing in on statistical data, and focusing on people first, then data.

I have always used a three-tiered approach to obtaining information. My suggested approach incorporates using several methods that will work well for anyone new to research and sourcing. I refer to these as:
- Conversation
- Observation
- Investigation

I enjoy talking with people first—so, naturally, informational interviewing comes easily. I also use my power of observation. Regardless of where I am, my eyes are constantly on the lookout for what is new, and what is happening. Finally, I guess you could say I am an information "junkie." I am always scanning through printed materials including trade and popular magazines, surfing online, and checking out the daily newspapers to see what new piece of information I can glean or use that could be of benefit to either my clients or students.

For those new to researching, the first two approaches will come easy. Naturally, chances are that you are doing these things anyway in your daily activities either on campus or while strolling in the mall. The heart of research is in conversations with others about their areas of expertise, or soliciting their insights. A simple observation can often lead to conversation with someone who is active in a particular area of interest—and *that* discussion might flow *naturally* to further investigation, eventually validating your intuition *and* your conversation! The secret is to become an *information junkie*. You must always ask questions as well as continue to look for the best place to find answers or sources to validate your hunches!

In this section you will be introduced to several individuals who are professional researchers. Wait until you hear their stories and advice! You will quickly discover how truly exiting sourcing can be.

Spotlight on *Cotton Incorporated*

Cotton Incorporated
6399 Weston Pkwy., Cary, NC 27513
Phone: 919-678-2220 / Fax: 919-678-2230
http://www.cottoninc.com

Congratulations . . . you have mastered Boolean search methods and garnered the skills you need to begin your journey to becoming a savvy researcher on the Internet for fashion!

In this section you will be spending your time with several key industry insiders and hear their insights to help you further develop your skills as a researcher and to apply that knowledge in the real world of today's fashion industry.

For most of fashion history it seems everyone's lives have been touched by cotton, so what better place to begin our industry insider secrets than with Cotton Inc.? (See Figure 6-1.)

You will soon discover that the **Cottoninc.com** site is a dream come true for the fashion professional sourcing for trends and other important information pertaining to the wonderful world of cotton.

Let's begin our introduction with an informational tour of what others have to say about Cotton Inc.

So, who *is* Cotton Inc.?
Barbara Murray, industry expert for Hoovers, notes, "Cotton Incorporated bolsters the US cotton industry through its research and marketing efforts. To

the general public, Cotton Inc. is known for its white-on-brown 'Seal of Cotton' logo, recognized by eight out of ten Americans—and its (now retired) advertising slogan, 'The fabric of our lives.' Established in 1970, Cotton Inc. is funded by growers of upland cotton and importers of cotton and cotton products. Its board consists of 54 cotton producers and 54 alternates representing more than 30,000 producers in 18 states. The company has offices in China, Japan, Mexico, and Singapore, and is overseen by the US Department of Agriculture."

Figure 6-1

The Cottoninc website is composed of numerous banks of data for the professional researcher as well as for the general consumer. This site is truly easy to visit with user-friendly navigation tools for you to use.

The website has some of the best tools on the Internet to research and source for fashion. Included are several features Cotton Inc. makes available for the industry professional. Cotton Inc. currently has a 125,000-square-foot facility located in Cary, North Carolina, that houses everything from a mini-manufacturing plant to research and development (R&D). However, there are other key offices also located in other major cities such as Los Angeles and New York. Cottoninc's forecasting services include:
• Color and trend direction for fashion apparel and interiors
• Consumer facts, trivia, and support
• Fiber and yarn production

In addition, Cotton Inc. helps promote cotton's competitive edge through:
- applied research that disseminates information, research reports, and technical bulletins of the latest information in a concise manner for immediate industry application
- the implementation of new and improved technology, both products and process
- direct technical assistance within the industry
- synergistic partnerships with various companies, machinery manufacturers, and textile mills, to provide an opportunity to share internal research and provide exposure to the latest innovations by industry suppliers

As you begin your journey as an industry professional, you can clearly see that Cotton Inc. can be a valuable resource. Now let's step inside the company and meet the people behind the logo.

In an earlier chapter we discussed that your job as a designer will often be to meet and work with experts from sales, marketing, and production. In this chapter I will take you inside the world of several successful researchers. Each does the work of resourcing and researching from a different perspective. I will begin by introducing you to several key staff members at Cotton Inc.

The first interview is with the director for Marketing and Planning, Kim Kitchings. Next, you will meet Claire Dupuis, a leading trend forecaster. Each of these women will share with you several aspects of their job along with their insights that will assist you in finding your place in the fashion industry.

Meet Kim Kitchings
Director of Marketing and Planning for
Cotton Incorporated,
located in Cary, North Carolina

Kim holds an undergraduate degree in business from Meredith University and an MBA from North Carolina State. She has been with Cotton Inc. for nine years working on a variety of strategic marketing projects.

The department Kim works in focuses on identifying information that is critical to understanding the markets for cotton. This includes the raw market for cotton such as pricing, imports and exports of cotton products, retail sales analysis

of apparel and home fashions in the United States, and consumer attitudes on a domestic and international basis.

They research and resource various topics that will at some point impact and heighten consumer awareness of cotton.

Kim's "Typical Day"
Like everyone I have ever interviewed, Kim confides that there is no such thing as a *typical day*. However, there are certain elements and aspects of her job that remain consistent. These include conducting roundtable meetings with her staff on a weekly basis and instructing departmental interns to canvass stores or websites to assess the presence of cotton at retail outlets in the United States. Kim also participates in interpreting consumer data and assisting in the understanding of its impact on strategic initiatives at Cotton Incorporated. Kim recently returned from a retailing conference and symposium held at the University of Florida. Such conferences often attract such notables as the vice president of Chanel and the multicultural director of Sears. They also, along with other executive education forums, keep industry professionals current in their learning

At some of the places, they typically look for this type of research in periodicals such as:
- *The Wall Street Journal* and trade publications such as *Daily News Record (DNR)* or *Women's Wear Daily (WWD)*. Online they visit the census bureau and other major government portals for statistical information. (This should all sound very familiar!)
- The department's goal is to be sensitive to all the influences on our culture and lifestyles, and how these trends can impact cotton. The team researches everything from the price of raw cotton to changes in population demographics and migration patterns.
- They also follow the off-shore migration of manufacturing and its impact on the United States. Although manufacturing of textile products has moved outside the United States (80 percent to 90 percent of all apparel purchased at retail in the United States is imported), there is still a viable portion of this industry left in the United States for designing and sourcing positions. Most of the data the team needs are gathered several times each year from travel to major global markets to garner the latest information or by attending strategic conferences.

According to Kim, the department is instrumental in investigating how well the industry has matched their technical scales of measurement to consumers' expectations of performance. For example, according to the American Association of

Textile Chemists and Colorists (AATCC) there are various numeric assignments that determine the level of colorfastness or smoothness for apparel, but the real question remains: Can the average consumer differentiate between a 3 and 4 or a 3 and 5 on a technical scale? And more important, will the consumer pay more for increased performance?

Kim's team supplements their research with proprietary sources of data. Finally, the team uses such companies as WGSN (Worth Global Style Network) and STS Market Research to determine and verify trends within the industry. This information is then analyzed and disseminated in the form of publications such as the *Textile Consumer* and Cotton Incorporated's *Lifestyle Monitor.* (Both of these can be found on their websites.)

Kim considers herself to be a "practical practitioner" who facilitates the process of gathering, evaluating, and assimilating the information for internal and external customers.

According to Kim, multicultural research is of the utmost importance. Kim was kind enough to provide me with permission to use her research currently available on the **Goodies CD> Cottoninc Resources. Goodies CD> PDF Folder>** *article entitled, Industry PDF files>* *1201TC Multi Cultural Consumers from Cottoninc.*

When asked to comment further on research strategies, Kim notes that the department is involved in both primary and secondary research that can include extensive ethnographic research. While this type of research is very costly, it is highly profitable to gather information about consumer buying and shopping patterns that they would otherwise be unable to articulate in quantitative type studies.

For those unfamiliar with **ethnographic research**, this type of research goes beyond focus groups and travels—it reaches where the customer actually lives. Companies visit consumer homes and observe their lifestyle and daily habits, including how they do laundry and what is hanging in their closets. This type of research can also be done in stores while consumers are shopping.

Kim's Insights and Secrets into the World of Research
When Kim was asked to share her insights on how she may gather this information, she discussed ways that are quick, easy, reliable, and many times *free!*

Kim also subscribes to my approach of:
• Conversation
• Observation
• Investigation

For example, let's say you want to determine how a new trend such as *the popularity of ponchos* may be relevant to the cotton consumer. Staff members or interns may visit five major retailers' websites or stores such as Wal-Mart, Target, Kohl's, Gap, or Belk to conduct a search on "ponchos." Information will be collected on fiber content, size availability, and even the price points.

Next, she may need to audit how well certain companies that are cotton driven might have performed in the last quarter. Let's use the example of denim where the search may include visiting the top five denim manufacturer or brand websites.

According to Kim, while the financial information may at first seem off-limits, a simple click on the company's web link for *Press-Releases* will often offer the target information she is looking for. For instance, in the case of how the last quarter's sales may have gone, including whether they posted a gain or loss, information can be obtained through other traditional sources such as Hoover's, and this particular method is referred to as a "quick jump start."

This information helps paint a picture of the current position of the company and helps in developing a tactical plan in working with this company. Much of this is later packaged for companies that use cotton products. A distilled version of the same is rewritten to educate the consumer at the cotton consumer website *http://www.fabricofourlives.com.* (See Figure 6-2.)

Figure 6-2

Issues that are the focus of Kim's team are multiculturalization and the *aging of the population*. Both of these trends and topics will have an impact on the buying and spending patterns of consumers.

When asked to reflect on the significance or her job, Kim remarked that she is "always amazed at major companies that fail to hire a research position because of such an important role they play in any company's future." Many forego hiring a researcher when times are good and then lament and attempt to ascertain this information only when times begin to get bad, and frankly, when it may be too late. The role of strategic forecasting information strategies can significantly avert disaster and be the catalyst for unrivaled success in the marketplace.

Kim's Final Advice!
Kim's final words of advice to any student are "ask questions . . . take the initiative . . . be a self-starter . . . follow up and follow through. When asking questions, attempt to connect the dots. Be open, alert, and stay inquisitive. Remember, don't be afraid to ask questions!"

FYI: The folks at Cotton Inc. are always interested in internships for those students pursuing a graduate-level degree.

It is always exciting to hear from the experts. The next individual interviewed at Cotton Inc. is no exception. While Kim keeps an eye on statistics and quantifiable information, our next industry expert takes her job to the road traveling the globe to confirm her intuition for the next big trends in fashion.

Trend Forecasting . . . Designing or Divining?
We can almost call this section "Is forecasting about designing or divining?" However, the truth is (just like in Kim's job) research combined with common sense, a lot of hard work, and a great eye that's been trained to spot the next direction in which fashion will be moving is the secret to success for today's designer!

Meet Claire Dupuis
Trend Forecaster for Cotton Incorporated
488 Madison Avenue, 20th Floor
New York, NY 10022

Claire Dupuis is a fashion trend forecaster for Cotton Inc., and is based at the company's marketing headquarters in New York. Claire monitors the marketplace of apparel and the crossover into home lifestyle while producing seasonal forecasts consisting of 36 colors. She consults with mills, major manufacturers, and retailers on a daily basis.

Claire first joined Cotton Inc. as the fashion manager of apparel for the company. She also worked for Tag-It Pacific, a leading source for trim and packaging. There, she worked closely with the sales and marketing teams to further the brand's development.

A graduate of Stephens College in Columbia, Missouri, where she earned a BFA in fashion design, she interned at several firms both in Los Angeles and New York City. Upon graduation she moved to NYC and found her first job through an alumni connection and a fashion-related employment service.

Claire has also freelanced as a textile artist while working in the trim industry, learning more about the world of fashion. That's why it wasn't long before the opportunity to work for Cotton Inc. came along, and Claire has been working as a trend forecaster since.

What Is the Role of the Fashion Forecaster?
So, what does the role of fashion forecaster include and how important is to have great research skills?

According to Claire, part of her job is to conduct thorough research on the latest trends through a variety of forums that would benefit Cotton Inc. The next and most critical step is to take all the information and begin to analyze everything that was gathered or gleaned, then translate this information into trends and support materials to be used for client consultations and fashion presentations. Finally, this information on the hottest trends is presented to partners, businesses, and consumers on a global scale.

Claire began our interview by detailing specific aspects about how a fashion forecaster does his or her job. According to Claire, she works on several timelines throughout the year—usually simultaneously. Typically, her seasons can be divided as follows:

• Presentations for mills begin in late October (for spring and summer seasons) and late April (for fall and winter seasons)

• Work is done 16–24 months in advance of the season, depending on the types of information

Claire went on to note that one of the most exciting and important aspects of her job is traveling. She has literally been all over the world seeking out the latest trends in fashion. The markets that Claire is responsible to report on are:
• Men's wear
• Women's wear
• Juniors
• Children
• Lifestyle apparel

When asked to further comment about the contemporary market and the interior market segment, Claire noted that there is another division specializing exclusively in interior design–related forecasting. However, there is no distinction between the women's market and the contemporary market at this time.

According to Claire, one area of special concentration is *lifestyles* where, along with her team, she focuses on a blend of global beliefs, identity, and people's preferences for certain products.

Claire's main areas of concentration are color, fabric, prints, and styling ideas. Color is the first thing to be solidified, followed by inspirational fabric ideas, and finally the silhouette direction. Her job is to always be asking questions—especially the question *why?*

One of the day-to-day activities on which Claire and her team might be working is making promotional materials that reflect her research from her travels abroad. They compile all the information gathered from travel and research and package it as exciting and informative trend reports and other support materials (for her clients) including:
• Strip cards
• Trend books
• Theme and mood boards
• Bullet point summaries of color, fabric, and other trends research findings
• CDs and other multimedia for presentations

Claire commented that, while much of this information is gleaned from travel, there is plenty of "presourcing research" that comes before she ever steps foot on a plane bound for another city or country. Claire and her team are all fired-up, active researchers. Research is the most integral part of their jobs. Claire reads *all*

the time, scanning the newspapers, trade publications, consumer magazines, and other periodicals while constantly on the lookout for fresh new ideas and developing trends.

With the advent of the Internet, sourcing online can involve a routine visit to major retail portals also known as *click and mortar* to spot new trends. Claire is also responsible for connecting with other members of the Cotton Inc. staff to discuss, collaborate, and share information and findings. Everyone approaches a project and the market from different perspectives. Some people might be data driven while others may be concerned with people. The coming together to network and share ideas is a pivotal priority to providing the client with the most reliable research results available.

One example of this in-house networking might be several key staff members assigned as representatives for major forecasting boards. These boards specialize in color forecasting for companies such as Premiere Vision and the Color Association of the United States. The information gathered here is analyzed and integrated into the research mix as it pertains to each market segment on which Claire reports.

Claire also noted that everyone in the market today is not only concerned with what colors will be important but also with the impact color matching has on the industry and the consumer. She also works with Pantone Inc. on the hotly debated topic of color.

Since we have devoted so much time to how to do traditional and nontraditional research, let's pause for a moment to discuss one of the more popular methods of gathering research: the **buying trip**.

The Virtual Buying Tour

Since this was such an important part of Claire's job, we asked her to elaborate a bit on her trips abroad to learn even more secrets to sourcing. So, let's pretend we are her traveling companions and discover the secrets to trend research! Open the **Goodies CD> Chapter 6> How to Conduct a Forecasting Buying Trip**. (See Figure 6-3.)

I wanted to know what markets are the hottest and most important to shop and why. Claire immediately replied with:
• Hong Kong is great for looking at new silhouettes.
• Australia is also important for silhouettes.
• Japan is perfect for denim and knits.

- Shop Turkey, India, and Malta—you will never come back emptyhanded.
- When it comes to Europe, London is a *must*. Not since the 1960s has London been more vibrant and alive with new ideas and trends.
- In Italy, from Rome to Milan, as an American traveler you can't help but notice and be impressed by the way both men and women

Figure 6-3

dress. It is inspirational. It is reported that "a single Italian male spends nearly 30+% of [his] disposable income each year on clothing, while the women (even the older women in Italy's bustling cities) display a personal sense of style and panache for dressing unrivaled anywhere, even in Paris."

Connecting the Dots

In the images in Figures 6-4 through 6-10 you can see where everything begins—with an inspiration or idea.

Claire has provided you a visual close-up of just how she takes her research and packages this information and inspiration for her ultimate B2B (business-to-business) consumer.

In the following pages we will take a closer look at how Claire brings her concept to the consumer.

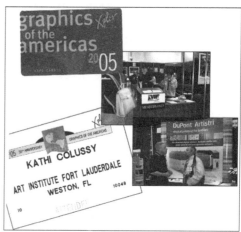

How to Visit a Trade Show

Visiting a trade show for the first time can be extremely intimidating. Show size varies greatly by industry. Fashion-related trade shows are held all over the globe. There are several key venues that represent various aspects of the industry.

Notes:

Figure 6-4

Figure 6-5

Figure 6-6

Typical categories for:
• Trade shows devoted exclusively to connect wholesalers to retailers
• B2B
• C2C (consumer-to-consumer)
• Retail to consumer
• Wholesale to consumer

Trade shows provide venues for:
• Products
• Supplies
• Services
• Equipment

Figure 6-7

There are a variety of trade shows for everything from apparel, shoes, and accessories to fibers and equipment. Let's begin by locating the right trade show for you and how to attend it.

For starters I recommend that you review the list of trade show websites located on your **Goodies CD> Open Chapter 7 folder> Tradeshows**. This file is also located on the **Goodies CD > At A Glance Folder> TradeShows.**

As you can see, there is an extensive list of trade shows from which to choose. This list is by no means complete—it is only a sampling of what you might need depending on what branch of the industry in which you find yourself working. We will assume that you have decided to attend the trade show titled <u>Graphics of the Americas</u> and that this event is held in Miami Beach. What do you do next?

Figure 6-8

Steps to Attending a Trade Show

- The best place to start is to visit the website for the show you are interested in attending.
- Log-on to *http://www.graphicsoftheamericas.com*. (See Figure 6-11.)
- Tour the site and determine the following:
 - Who is sponsoring the show?
 - What types of vendors will be exhibiting? (See Figure 6-12.)
 - Who should consider attending this event?
 - What kinds of products and services can you expect to find if you attend?
 - Are there any seminars being offered? If so, what are they? Are there fees to attend?
 - Would this be something you would in all likelihood want to attend and why?

Figure 6-9

• Determine if there are any special arrangements or agreements for travel:
 • Are there local hotels, airlines, or rent-a-car companies that have special agreements for visitors or attendees?

Hint: Call or go online for the hotel, airline, and car rental and compare prices. Are these the best prices for you? With the plethora of online travel services available it may be worthwhile to compare prices. However, usually you will find that rooms for these events book up fast, and being centrally located to an event can offset the small saving if you choose to book on your own. But it never hurts to ask or search for a better deal—you never know what you may find!

• Determine if there is an entrance fee and what kind of identification or credentials you will need to attend.

Figure 6-10

• If you are a student, can you attend, and is there a discounted fee?
• Is there a toll-free number in case you have questions?

A week before the show:
Well, it is almost time to travel. What should you do to be better prepared?
• I suggest you go back online to
 the show's URL and look for the vendor section of the site. (See Figure 6-13.)
• Try to predetermine which booth(s) you want to visit. Place a ranking order on
 what you want to see.
• Print out the information and evaluate whom you want to see.
• Make a list of the vendors and the numbers of their booths.
• Visit the companies you wish to see online first. Determine who will be there at
 the show and if the company has any "virtual" promotional materials for you
 to preview. Print those and see what questions may be answered from the
 Web. Sometimes these answer all your questions and you may be able to repri-
 oritize your stops. Sometimes answers lead to more questions. Make the time
 to previsit a trade show online!

Figure 6-11

Figure 6-12

- Write down your questions beforehand and bring them with you to the show.
- Why not call the company to find out how significant of a presence it intends to have at the show? I wanted to visit a certain company to view their latest equipment only to find out that it would not be at the show.
- Determine if there are any incentives to buying at the show, if you are a serious buyer.

Notes:

Figure 6-13

Traveling Like a Pro

Have you considered how and what to pack?

In this section I will introduce you to Travelpro International, Inc. executives Kim Ballis, CEO, and Marcy Schackne, vice president of marketing.

When it comes to traveling and packing you should learn from the company that defines travel: Travelpro. (See Figure 6-14.) As an industry insider, Kim discussed with us the benefits of investing in great luggage.

Travelpro was founded by a 747 airline pilot who recognized the need for luggage that was practical and versatile for the frequent and professional business traveler. Travelpro originated the wheeled luggage we all have come to know. Kim took the original concept of the company to the next level of innovation with a variety of patented features that make traveling a breeze. He noted that the company has launched luggage that is up to 25–30 percent lighter weight than traditional luggage.

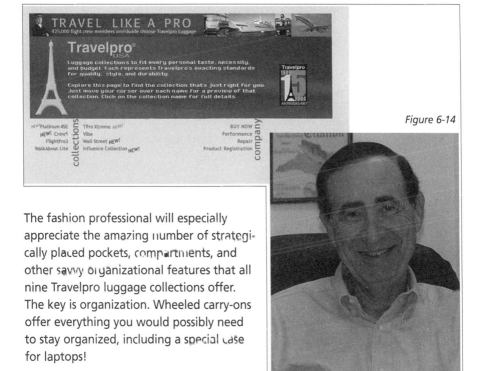

Figure 6-14

The fashion professional will especially appreciate the amazing number of strategically placed pockets, compartments, and other savvy organizational features that all nine Travelpro luggage collections offer. The key is organization. Wheeled carry-ons offer everything you would possibly need to stay organized, including a special case for laptops!

Naturally, the luggage is made from the highest quality denier of nylon that has been DuPont Teflon coated to protect the luggage exterior. The bags also include industry award-winning, no-tip feet on the base that help stabilize the bag from tipping, and key wearpoint guards to protect corners from the normal wear and tear of travel. The patented ProGrip handle on the Platinum collection extends the height of the handle for taller individuals without sacrificing the center of gravity. In addition the luggage has proprietary framing that provides additional strength and integrity to the luggage to enhance the lifespan of your purchase.

Kim, who personally logs over 150,000 miles per year, recommends the 22-inch carry-on seen in Figure 6-15, which is

Figure 6-15

used in the sample of how to pack on the **Goodies CD> Chapter 6> Pack like a Pro to Visit a Tradeshow.**

According to Marcy, vice president of marketing, the latest trend in luggage is light, strong, well-thought-out, organized compartments. In fact, both Marcy and Kim went on to say that Travelpro is specifically addresses the female business traveler, with a new line called *The Runway Collection.* Travelpro is always about quality and innovation and, according to Kim, "the purchase of good luggage is an investment in your future." I couldn't agree more!

For a complete list of Travelpro luggage and suppliers, visit the website *http://www.travelpro.com.*

Now let's look at how to prepare and pack for a trade show.

Packing Like a Pro to Visit a Trade Show

Now that you can consider yourself an informed traveler on what luggage will meet your travel needs, you are ready to consider all the other possibilities for making the most of your packing experience for almost any business travel, including attending a trade show. Soon you will discover how being informed on luggage options can translate into a successful business trip or a successful trade show! Open **Goodies CD> Chapter 6> How to Visit a Tradeshow.**

In a best-case scenario, assume you are arriving the day prior to the show and leaving the morning after the show concludes. Let's have a look at your travel packing checklist:

Travel *musts:*
• The smaller the suitcases the better, unless you want to bring home (from the trade show) a ton of printed material. In this case, having a larger suitcase that is half full will be helpful.
• Buy great luggage—it should be a given that your suitcase has wheels. In addition, an easy-to-tote carry-on will make traveling a breeze. I suggest the Travelpro brand. (See Figure 6-16.)
• By all means visit *http://www.weather.com* and determine what other items you might need such as a raincoat or umbrella. It pays to always carry *both* anyway!

Figure 6-16

- Bring business or career apparel such as a navy pantsuit or skirt or dress for women. The same goes for men—a navy suit says "trust me, I am a professional!"
- Fabrication should depend on the time of year and geographical location of the show. Even in Florida, tropical-weight wool or light weight wool crepes are terrific for travel. No wrinkles, no worries because the fiber breathes. Translation: It is trans-seasonal! Honest! The word *gabardine* means "Hebrew cloth"—yes, that is what Moses wore in the desert. You know it is the right fiber that goes from the heat of the day to the cool of the night (sure sounds like a winner to me!). While cotton is always comfortable, use discretion when purchasing. Look for fabrics that will help you avoid wrinkles. Also, the downside to some cotton fabrics is they appear too casual, yielding the "I am on vacation" look! For women, I suggest rayon fibers in crepe fabrics. They travel light because the fiber is a cellulose combination that contains cotton linters which help the fabric be comfortable while still looking crisp and sharp.

- You can always pack some less structured clothes for your next day if you want to go to the trade show unnoticed or remain low key. Determine which days will be the busiest and which days might be slow. Dress accordingly. Sometimes dressing low key on busy days allows you to walk around and get the feel for the show. The idea is to take in what is there and which booths you really want to visit, and then come back the next day "dressed the part" to get the answers you need.

- Accessorize—especially women. You can appear more casual or trendy with great handbags, scarves, and jewelry. For both men and women, the color of your shirt or blouse is important. I repeat: Avoid the too-casual vacation look. You are there to get information and the way you look counts. So, if you are young and attractive *(lucky you)* but dressing like a celebrity is fantasy, you may be missing the real objective. This is *real life* and your career. There is a

difference between the bedroom and the boardroom so, if you want to be taken seriously, think and *dress for success!*

- Oh yes, wear comfortable shoes! You do not have to look like a "schoolteacher." There are several styles that look terrific and still offer you some degree of comfort. You can't enjoy the trade show if your feet are killing you. Trust me, I know that walking the shows for several hours can be grueling if you are walking in heels.
- Always, always bring business cards. Even if you are a student, have inexpensive cards printed. Cards should have the following information:
 - Your name
 - Company name
 - Address
 - Phone numbers (business and cell)
 - Email and URL
 - Area of expertise or job title
- Carry a day-timer or notebook or bring a PDA if you can afford the luxury of the latter.
- Other luxury considerations are cameras and laptops if they are appropriate to bring to the show. Otherwise leave them in the hotel; they can be cumbersome to *shlep* (translation: *carry*).
- Consider bringing a folding tote with you to carry all the print material you will be collecting. Also, be sure to find out if the printed material at the booth is available online. If it is, it will mean one less thing to carry.
- Bring at least two pens in case you set one down and lose it.
- Develop your own predetermined rating system for ranking the significance of the booths you visit. Decide which booths you *must* visit and whom you *must* meet.
- Ranking and annotating business cards is helpful.
 - Annotate information on the back of each business card you collect from the show by jotting down some quick data to help you remember what you need to know about the person, the booth, or the company. You will thank yourself later!
- Always follow up with a *thank-you* email if you found the person and the information useful. Even if the person was not helpful but you wish to still deal with the company in the future, a well-written thank-you email will say a wealth of positive things about you and your professional manner.
- Follow up by reading reviews and write-ups about the show in major trade publications or visit URLs that specialize in industry evaluations.
- Finally, don't be afraid to ask questions.

Note: The above article is an adapted reprint from an article written for an E-zine (http://www.computersandfashion.com) and used with permission from the author.

Notes:

Profile: [TC][1] and Techexchange.com
So, who is [TC][2]?

As a fashion professional, one company you will want to know about is [TC][2]. In 1979, the initial concept was generated from a National Science Foundation study conducted by John I. Dunlop and Fred Abernathy of Harvard University. [TC][2] was founded at Tailored Clothing Technology Corporation to conduct R&D activities. (See Figure 6-17.)

Participation swelled, and [TC][2] has been formally endorsed by the American Apparel Manufacturers Association, now known as the American Apparel and Footwear Association.

Here is a brief list of AAFA's accomplishments over the last several years:
1998 - three-dimensional body measurement systems made commercially available
1999 - four 3D body measurement systems delivered

Figure 6-17

to Levi Strauss and Co. (San Francisco, CA), U.S. Navy, North Carolina State College of Textiles, and Clarity Fit Technologies of Minneapolis
2000 - the launch of Lands' End

[TC]2 is recognized for its involvement in empowering the industry through a wide variety of industry support materials (see Figure 6-18) and with industry training (see Figure 6-19).

It is especially applauded for the advancement of 3D body-scanning technology. (See Figure 6-20.)

Spotlight on *Ink Drop Boutique*
In addition, [TC]2 is affiliated with the Ink Drop Boutique. (See Figure 6-21.)

Figure 6-18

Figure 6-19

Figure 6-20

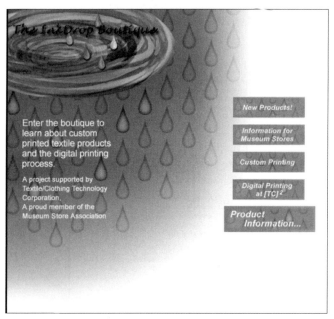

Figure 6-21

The Ink Drop Boutique is recognized for its excellence in digital printing solutions, color management, finish and processing expertise, along with a wide variety of services, products, and vendors and industry affiliations. Look at Figures 6-22 through 6-26.

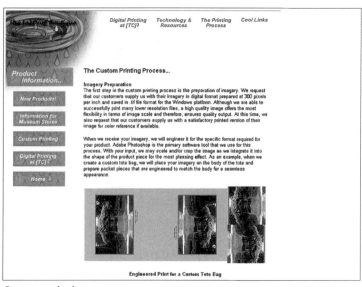

Figure 6-22

Custom printing

Figure 6-23

Color Management
Before printing your product we will prepare a color corrected sample for your approval. Using the printed sample that you have provided as a reference, we will make color adjustments to the digital file to ensure the most accurate color reproduction possible in our environment. We also prepare color profiles for each printer, ink, and fabric combination that we work with. Once we have completed the color correction process, we will print a sample for your approval.

While digital printing offers tremendous capabilities in terms of color and image detail, we occasionally encounter limitations to the process. However, we will do our absolute best to achieve optimum results within the capabilities of the 6 and 8 color technology we currently work with. Also, keep in mind that the color management process can be fairly time consuming and does involve modest consumption of raw materials. With this in mind we charge a small one-time fee/design for this procedure. However, your color corrected image will be kept on file for re-orders.

Color Correction in Adobe Photoshop

Creation of Color Profiles for Fabric, Ink, Printer Combination

Color management

Figure 6-24

The printing & finishing process
We will use one of two devices and specialized software to print your order. Our **Fabrijet printer** (by MacDermid ColorSpan) is typically used to print all of our scarves. We operate this printer in an 8-color mode using ColorSpan's Colormark software for the reproduction of process color imagery. Our Mimaki TX1600s is used to print most of our tote bags and cotton accessories. We operate this printer in a 6-color mode using Ergosoft's Texprint software for process color imagery. Using specialized software (Proofmaster by DPInnovations), we also have the capability to produce samples of traditional spot-color textile imagery. Please inquire if you are interested in this option.

In preparation for printing, your product pieces will be nested for maximum fabric utilization. Colors and styles will also be grouped for maximum efficiency during the finishing process. Most of our fabrics are currently printed with reactive dyes that require steam fixation for color permanence and washing to remove excess color and fabric pretreatment. All fabrics have been specially pretreated for the inkjet process to enable optimum image quality and color fixation. The chemicals used in the pretreatment process are similar to those found in the print paste used in the traditional screen print environment.

Following the steaming and washing process, the printed fabric will be checked for quality and the product assembled and packaged. This is the most exciting part of the process - custom printing means that there is always something new and interesting being created for our customers. And just like you, we enjoy seeing the concept become a reality!

Scarf Samples being Printed on the Fabrijet Printer

Custom Scarves Grouped and Printed According to Size and Color

For more information about custom printing contact Kerry Maguire King (919-653-3523) or Lujuanna Pagan (919-653-3508).

Finishing and processing expertise

Figure 6-25

Exhaustive vendors and suppliers

Figure 6-26

Industry affiliations

Showcase: Techexchange.com

Another major holding for [TC]² is the recent acquisition of TechExchange.com. The current publisher of this website, a gentleman by the name of Jud Early, is a member of the [TC]² board of directors. For those unfamiliar with Techexchange, it is an important industry website originally founded by Teri Ross of Imagine That! In recent years the site was sold to [TC]² and is recognized as a B2B as well as an educational site for the fashion industry, particularly in the area of CAD (Computer-Aided Design). (See Figure 6-27.)

Several great features of the Techexchange website include the library and the database—everything from white papers to suppliers.

Let's follow one of the links so you see just how this site works.

Imagine that you are working for a company that needs to research more on purchasing CAD software, and specifically software that specializes in textile design. Where do you begin your search?

Figure 6-27

Defining CAD for Textile Design

Today, designers can be armed with fantastic software tools that allow them to still meet demands with smaller staff and, hopefully, less overtime. Finding the right tools for all their needs is the key.

Looking at the market, there are many software packages from *off-the-shelf* to *proprietary*, that allow a designer to do these tasks. However, there needs to be a focus on exactly what the design software will be used for. Off-the-shelf refers to design software like **Adobe Photoshop** or **Illustrator**. Proprietary refers to design software designed for a specific industry, like **Pointcarré**, **NedGraphics-Artworks**, or **Lectra-U4ia**.

These proprietary design programs are written for the development of textile and apparel design. There will be a cost factor as well. Off-the-shelf is lower in initial cost than proprietary; however, a designer may spend more time learning the proprietary software in the design stage compared to its traditional off-the-shelf counterpart.

From the Techexchange website, you can first resource the library for white papers and current news. (See Figure 6-28.)

Figure 6-28

You can also look under the link to find what trade shows might be coming up and are within range of the company's budget for you to travel to. (See Figure 6-29.)

Next, you can go to the B2B section to locate suppliers. (See Figure 6-30.) This includes advanced search (see Figure 6-31) capabilities.

Once there, you can follow the links to some of the more popular companies that have been listed and possibly advertise and contact them directly. (See Figure 6-32.)

In our example we followed the links to Pointcarré USA software located in New York City. This company specializes in software solutions for color and color reduction; textile design including repeats, wovens, and knits; as well as presentation software that does texture mapping and storyboarding. (See Figure 6-33.)

From there you might contact Pointcarré directly, and speak with a salesperson for an online or in-person demonstration, or even a free trial demonstration.

Figure 6-29

Figure 6-30

Figure 6-31

Meet Gabrielle ("Gabby") Shiner-Hill

My industry insider information for Pointcarré USA
came from Gabby Shiner-Hill. Gabby is one of the
head trainers at Pointcarré as a CAD specialist and free-
lance textile designer. Gabby graduated with a BA (hon-
ors) in textile design from Central St. Martins, specializ-
ing in weaving.

Figure 6-32

Figure 6-33

Gabby has been teaching weave, print, and knit design and developing Pointcarré software for more than two years. During her tenure at Pointcarré, Gabby has been instrumental in training clients such as employees of Tommy Hilfiger, Ralph Lauren, Michael Kors, and Calvin Klein. During this time, Gabby has also freelanced for Calvin Klein Home. Prior to moving to New York Gabrielle worked in London designing men's shirts for the High Street market Topshop, Debenhams, and so on.

I also spoke with the manager of Pointcarré, Steve Greenberg, who said, "Converting to digital designing and going beyond off-the-shelf software is becoming a must for managing the work flow and design process." According to Steve, "companies need this kind of software to manage their files, to design, recolor, edit and edit again. These are the repetitive processes that design software allows us to accomplish quickly and easily. Increased demand for CAD art as well as the need for quick turn-around in art and sampling has created a new area of design, the **CAD Operator** or **CAD Designer**."

Why Pointcarré?
In an interview I asked Steve to elaborate more on *why Pointcarré?*

Spotlight . . . Pointcarré
Pointcarré has been developing proprietary apparel and textile design software for almost 15 years. With a diverse product line that is both Macintosh- and PC-based, it has always provided its clients with excellent service, training, and software support. The New York office, *Pointcarré USA*, supports diverse clients such as Nautica, Tommy Hilfiger, Polo Ralph Lauren, Eddie Bauer, the Metropolitan Museum of Art, Town & Country Living, and Kmart.

Pointcarré provides powerful, customizable, and user-friendly technology that designers find easy to use. That's what its solutions are about. Pointcarré USA provides CAD solutions at all levels for surface design. From woven and knits to textile prints, photo-realistic texture mapping and embroidery, it is well known for the amazing quality of fabric simulations produced by its software.

Fabric or surface design, merchandising, storyboards, and texture mapping are all different abilities and outcomes of any design project. Cost savings and turn-around time are also important to the company. The designer using it must evaluate the tasks for which he or she will be using the software and then research all possible program options, to be sure it will fit his or her needs. Any designer

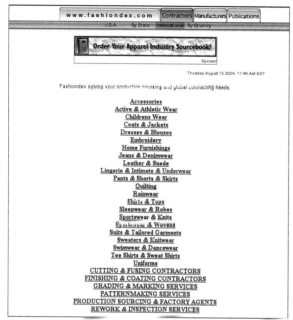

Figure 6-34

will find that there may not be one software program that *"does it all."* He or she may most likely need to use two or three software packages in order to accomplish all the company's design needs.

Pointcarré USA is committed to educating the fashion and textile designers of today and tomorrow. Colleges that use its software include North Carolina State University, Fashion Institute of Technology, Parsons School of Design, Philadelphia University, Rhode Island School of Design, and the Art Institute of Fort Lauderdale.

Steve mentioned that, in addition to online support, the company maintains a high-profile trade show presence at many of the major venues for fashion, where Steve and his team are on hand to conduct live, hands-on demonstrations of the software.

One Last Secret . . . *FashionDex*

(See Figure 6-34.) It's an *amazing* secret: a company by the name of FashionDex, specializing in distributing a wide variety of industry print materials and subscriptions. It even has an online bookstore. (See Figure 6-35.)

FashionDex also self-publishes information you may not be able to find anywhere else. The bookstore has a complete list of *directories*. (See Figure 6-36.)

There are several key books that I recommend:
• *Contractors: Asian Market Edition*
• *Contractors: American Market Edition*
• *Apparel Products and Services*

Figure 6-35

The last text provides complete company names, addresses, URLs, phone numbers, and contact personnel! You will find the following resources are included as well:

- Knit swatches and design studios
- Knitted trims
- Novelty trim
- Dyeing and finishing houses
- Converters
- Fabric agents and distributors (globally)
- Greige good suppliers
- Home furnishing fabrics
- Fit model agencies
- Forecasting services
- Freelance design studios
- CAD vendors and much more

Figure 6-36

The URL is ***http://www.fashiondex.com*** and it is real stress- and time-saver!

Well, now that you have heard from several industry experts and have gleaned valuable information and insight from them you are ready to head on to our next chapter. There, I'll introduce you to several of the leading websites for almost every imaginable area of research you could possibly need as a fashion professional.

There are also these reference aids on the **Goodies CD> Chapter 6>**
How to Conduct a Forecasting Buying Trip
How to Attend a Trade Show
How to Pack Like a Pro

7. Strategic URL Listings at a Glance

This chapter, which is also included on the CD, covers the following topics:
- Business and marketing information
- Demographics and psychographics
- Color and trend forecasting
- Government sites
- Trade associations and industry publications
- Employment
- Fiber, fabric, findings, jobbers, and production sources *and much, much more*

In this extremely short chapter, which is located on your Goodies CD> Strategic Resources at a Glance, you will find an alphabetical listing for many notable URLs you will need to know as a fashion research professional. Many of these sites can be considered Deep Web and many have their own databases or search engines within the site to enhance your research. I suggest that you become familiarized with the sites and know how they work. Determine if they have advanced search features such as site navigation. Definitely jot down your findings and be sure to *bookmark* your favorites.

Most important, recognize that the industry as well as the Web is *organic* and is everchanging and evolving. Therefore, the listing, though accurate at the time of printing, may have changed (e.g., a company merger may have occurred, websites may have been upgraded, or URLs may have changed). So, do not become frustrated if the URL you are looking for has moved or perhaps is no longer in existence. Simply try another method for locating the data you need.

Remember, the best thing to do when visiting a website for the first time is to take a look at the links. Many times you will discover that there may be easier ways to find information on your topic and it might be right at your fingertips. Follow those links!

One last thought as you discover new listings that may be beneficial to all of us: Log-on to *my* website, ***http://www.computersandfashion.com***, and drop me an email with your recommendations!

There are also these reference aids on the **Goodies CD> Chapter 7>**:
- Apparel Listing Generic
- Art—Artist and Art Sources
- B2B Links
- Business and Marketing Sites

- CAD and Design Studio and Services
- Care—Labels and Standard Info and Educational Resources
- Computer and Software
- Digital Image Links
- Educational Resources for Fiber-Fabric—Research
- Encyclopedias-Dictionary and more
- Equipment—Industrial
- Fashion Specific Dictionaries
- Forecasting Services
- Historical Fiber—Fabric Research and Sources
- International Fashion Resources by Country
- Merchandise Marts and Retails Trade Info
- Print-News-Magazine and Other Online Media
- Retail Resources
- Shopping Bots
- Textile Glossary and Dictionaries
- Trade Show Links
- Travel
- Trends and Stats
- US Government
- World Trade Links

Notes:

8. Sourcing Exercises

Exercises: How to Conduct Advanced Research Online. Now It's Your Turn!

From Good to . . . Better to . . . Best . . . the Quest for Solutions and Answers!

In this chapter you will put into practice what you have just learned. I suggest that you try different search engines and explore several different methods of posing your question. Experiment: Compare search engine results and compare and contrast the top ranking sites when you rephrase or pose your query. For now, the goal is progress—from good to better to best—by simply seeking to apply a variety of strategies. Using what you've recently begun to master, you can continue to become a more successful researcher.

Try practicing with a peer. You should each *work on the exercise separately*, then *compare strategies and answers*. Evaluate how you did and determine which of you got the best responses and why.

Remember, much of what you will be looking for will fall under the Deep Web category, so don't be afraid to revisit sites that you know have strong industry-specific links.

You'll soon realize that investing a bit more time when you venture across a great industry site with strong links is well worth the investment, saving you time and energy later. Always annotate the bookmarks you come across. Do not hesitate to turn to traditional resource methods including trade organizations and libraries. The best-kept secret is to always maintain and foster your network of industry insiders. Having an expert that is only a phone call or email away is a real advantage and time saver.

Sourcing Exercises
Before you begin the exercises it may be helpful to take a quick refresher tutorial on how to conduct advanced research online. Go to any major search engine and type Boolean Logic Tutorial.

I recommend ***http://www.searchability.com/***, owned by Paula Dragutsky, a former librarian and freelance researcher.

List the URLs you used along with your notes on the Boolean logic tutorial here:

Narrowing Your Search at a Glance
The Thought Process and the Key Strategies at a Glance

As you begin to take the challenge exercises and the **Goodies CD> Chapter 8> Scavenger Hunt,** you may find it helpful to review one more time the different ways to pose your query.

• *Keyword search*
• *Phrase search*
• *Image search*
• *Natural language search*
• *The use of operators and limiters—AND, OR, NOT, *, (+), (-), and so on*

Let's begin by trying to find the list of members of the official Paris fashion houses. Begin to jot down a list of questions or thoughts that may help you begin your query, such as the keywords *French Fashion*. Obviously this would be too vague and far too broad in scope, so you may wish to use a more specific phrase that describes French fashion such as *Haute Couture*. Perhaps you know the name of a designer at an elite French fashion house and you wish to type in the name of the house (or maison) of Yves St. Laurent. Again, chances are this is far

too broad and will possibly result only in taking you to retail-related sites. However, a detailed search may lead you to the St. Laurent-Pierre Berrge Foundation (http://www.ysl-hautecouture.com/) which may provide you with more information.

The next strategy is to begin thinking about what types of information you may have learned in other classes that pertain to French fashion. Perhaps you are familiar with the organization that oversees French fashion—the *Chambre Syndicale.*

Let's have a look at the results from Google for Haute Couture. (See Figure 8-1.)

Now, let's see the results for Chambre Syndicale AND Haute Couture. (See Figure 8-2.)

As you can see, the phrase *Chambre Syndicale* along with using the Boolean operator *AND* and the keyword *Haute Couture* results in your search being considerably narrower with only 6,150 choices versus 845,000 results!

Finally, you will notice that timeline relevancy can mean *everything* (see Figure 8-3) when it comes to fashion. So, watch for the dates of your results.

Figure 8-1

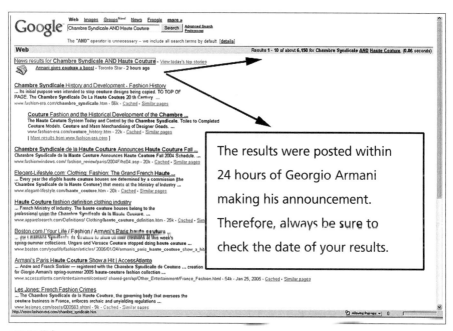

The results were posted within 24 hours of Georgio Armani making his announcement. Therefore, always be sure to check the date of your results.

Figure 8-2

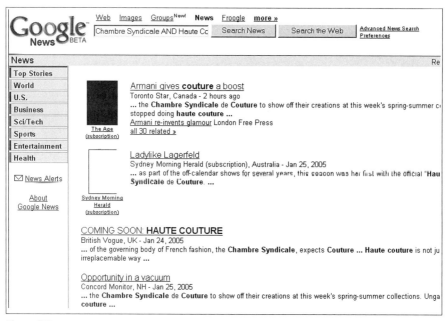

Figure 8-3

Finally, a word of caution: The results I garnered on a given day in January 2005 may be vastly different from your results at some point in the future. Remember, the Web is *not* static but is very organic. And, while *my* results were the most up-to-the-minute for the time, *your* results will vary.

Now that you have had a quick refresher on how to search and how to narrow your search, you are ready to tackle some of the typical search scenarios in which, as a fashion professional, you may find yourself. So, let's begin!

Designers often find themselves, particularly after gathering some strong solid research, looking for ways to cut costs. Since fabric is the most costly single expense in garment production, finding the right fabrics at the right costs is crucial. Many of the next few exercises were designed to train you to seek out the best resources available today.

Sourcing Exercises
Exercise 1
Find a leading novelty button company.

Exercise 2
Find an embroidery lace for women's lingerie.

Exercise 3
Find a leading zipper supply company.

Exercise 4
Locate five different stores, and their corporate buying offices.

Exercise 5
Find out how the leading retail stores view apparel sales for the next year.

Exercise 6
Use two different trade sources and identify a leading men's wearhouse for the upcoming fashion season.

Exercise 7
Make a list of five different trade shows in the next 90 days. Identify each location, the major focus of the show, and how to submit an application to show and market merchandise.

Exercise 8
Find trade shows scheduled featuring yarns or knitting equipment.

Exercise 9
Find a website on computer systems for pattern grading for fashion.

Exercise 10
Find a website that tells what your favorite fashion designer is currently showing on the runway.

Exercise 11
Find a website that features ethnic prints from Africa.

Exercise 12
Find some research on dress designs of the 1920s, 1930s, and 1950s.

Exercise 13
Find information on fashion from the Middle Ages (Gothic).

Exercise 14
Find information on one of the natural and one of the synthetic fibers.

Exercise 15
According to "Beyond Design: The Synergy of Apparel Product Development," by Sandra J. Keiser and Myrna B. Garner, the U.S. Census Bureau expects the Asian American population to double to 23 million by 2020. In addition, Asian American spending power has increased by 102 percent in the past decade according to the Selig Center for Economic Growth. Even the *Lifestyle Monitor* by Cotton Incorporated reports that women in this demographic like to shop more than the general population as a whole, and they are offended by the lack of advertising messages and images that tend to neglect this market.
Part 1: Much of this population falls into the petite market category. Find three websites that relate to demographics and three sites that relate to psychographics on this market.
Part 2: Determine whether other cultures also experience an unusual growth rate that needs to be targeted by the petite market.

Exercise 16
Production vs. Mass Customization vs. Vast Customization
What are the main differences among production, mass customization, and vast customization? Where is the best place to search? What might be the best ways to pose this query? How might I find a presentation explaining the differences? Are there any online industry exchanges that may have this information?

Exercise 17
Image Search Engines Revisited
You recognize that Greco-Roman influences are becoming more and more evident on the runways. Where can you turn? Perhaps you start with a natural language query of "What is the name of the gown worn by ancient Greek women?" The first result offers you only text information of an item known as *chiton*, and may not offer you visual image of what this item looks like.

Therefore, why not take that newly found term, *chiton*, and go to a search engine that offers image solutions and type in the keyword *chiton*. There you go . . . several great thumbnails of images scattered throughout the Web of what a chiton actually looks like. This beats scrolling through endless results on a text request that may or may not locate an image for you to review.

Image search engines are terrific for most fashion professionals who are essentially visual by nature. The only recommendation is to be sure that you have cross-referenced your results with a reliable text reference site. It is worth the extra time and effort to be sure your image results are accurate.

Now find a website that has accurate information on the legal use of images—you may also find articles on copyright law.

Exercise 18
Historical Searches
1. Search for a western costume timeline.
2. Locate a history of haute couture.
3. When were the following invented?
 a. The zipper
 b. The sewing machine
 c. Velcro
 d. Nylon
 e. Tencel
4. Find the history of the following:
 a. The bra
 b. The purse
 c. Men's suits
5. Find a site that specializes in regional historic costume of any country in Latin America.

Exercise 19
More Fashion Scavenger Hunts
Locate the following:
Stores
6 major department stores
2 specialty stores
5 boutiques

Shoes
35 shoe brands/firms
 1 popular-priced shoe brand
 1 moderate-priced shoe brand
 1 better-priced shoe brand
 1 designer-priced shoe brand
 1 designer men's shoe brand

Women's Clothing
1 petite designer label
1 plus size swimwear label
1 contemporary dress label

Juniors
1 junior swimwear label

Children's Wear Labels
15 children's wear brands or labels

Men's
1 designer men's wear suit label
3 men's shirt labels

Sweaters
25 sweater brands

Handbags
5 designer handbag labels

Accessory Brands
15 accessories labels

Millinery
15 millinery labels

Notes:

Lingerie or Underwear
15 lingerie or underwear brands

Outerwear
15 outerwear (or coat) brands

Vintage
5 vintage clothing sites

Production Hunt
Locate the following:
2 textile jobbers (wholesale companies
 that manufacture apparel or other
 items by the job for other companies)
2 knitwear jobbers
2 woven jobbers

Notes:

Exercise 20
General Computer and CAD-Related Exercises
Find articles or information on the following topics:
• Find the definition of and distinction between the terms *CAD* and *CAM*
 as they apply to fashion.
• Discover the latest emerging technologies in CAD/CAM.
• Find a tutorial on search engine math.
• Find a website that specializes in virus and spam protection.
• Locate a list of suppliers for proprietary CAD software.
• Locate three major suppliers for computer hardware.
• Find one URL that specializes in evaluating computers and/or software.
• Find the leading image-editing software.
• Determine how much data can be stored on a CD.
• Research what other alternatives a designer has for storing back-up copies of
 their work.

Bonus—go to the **GOODIES CD> Chapter 8>CAD FOLDER SUPPLIERS.**

Exercise 21
Nonfashion Exercises
Search Engines
1. Locate three shopping bots:
 a. Find one that specializes in textbook sales.

b. Find one that offers specials for technology-related items.

c. Find one that specializes in clothing.

Travel Exercise

1. Find five online sites that specialize in discount travel.

2. Get price fares from Fort Lauderdale to Las Vegas for June of this year for seven days. Now, access all five site results to compare and contrast in order to evaluate which has the best prices.

3. Find the name, number, and website for five train companies (globally, not just in the United States).

4. Find one site that provides *free* info on packing.

5. Find one site that has currency exchange information; be sure the site gives you the following exchange rate:
 a. The U.S. dollar and the English pound
 b. The Yen and the Euro
 c. The Euro and the U.S. dollar

6. Find three URLs that specialize in travel-specific clothing.

7. Find three URLs for luggage companies that specialize in carry-on-style bags. Compare and contrast features within the following price points: popular, moderate, and better. In each category of price, which brand appeared to have the best features?

8. Locate several *free* websites that provide you with things to do in the following cities:

Paris	Milan
London	Frankfurt
Miami	Dublin
New York	Hong Kong

Exercise 22
Museum Exercise

1. Locate 20 major museums in the United States and 20 major museums in the world that specialize in art (be sure to not select museums on war, technology, or other nonrelated sites).

2. Find 10 museums that specialize or have a section devoted to costume (these can be repeats from the above list). They can be from all over the world, not just the United States.

3. Find two museums that specialize in shoes and two that specialize in textiles.

Exercise 23
Career Exercise

Locate a list of job opportunities online for the list below. The jobs can be anywhere in the world. Next, of the job titles below select three that interest you and attempt to locate a position for one of these jobs in your area.

Artist
Assistant print designer
Buyer
CAD artist
CAD designer/engineer/operator
CAD/CAM designer
Colorist
Converter
Decorative artist or designer
Design editor
Designer
Design assistant
Design director
Design technician
Fabric development specialist
Fashion designer
Freelance artist
Graphic artist/designer
Jacquard designer knit or woven
Knitwear designer
Lace designer
Marketing
Print artist/designer
Product development designer/specialist
Repeat artist
Sales representative
Sketcher
Stylist
Sweater designer

Technical artist/designer/assistant
Textile technologist
Textile stylist
Textile designer/artist/trainee
Tie or print designer
Wallpaper designer
Woven designer
Visual display
Your choice . . .

Company Research
Now is the time to do your homework (*before* you have your first interview for a job) about the companies to which you will apply. To the recent college grad, searching for the right job can often be daunting. Now, thanks to the Internet, you have your own career advisement center only a few clicks away.

1. Begin now to think about the following considerations:
 a. How can you find out about the company prior to the interview?
 b. What do you think the company policies might be? How rigid or structured is the company? Is it a large company or a small company?
 c. What kinds of advancement do think there is within the company?
 d. How many offices or locations are there? Where are they located?

2. Where do you start? What kinds of information are you going to be searching for? I suggest you start this section with the following links:

http://www.careerbuilder.com and http://www.hoovers.com.
Next, be sure to annotate your results and findings below.

Exercise 24
Other Career Considerations
Let's assume the job you wanted was *not* within your local area and would involve moving. This means you need to determine whether the salary and the cost of living in this new location are compatible with your budget and your goals. Let's take a look at some other considerations:
• Where do you begin to search for housing?
• Where can you find prices on what the housing market in that area has done within the last 12 months?

- What is the general cost of living in this region?
- Do you need to consider schooling—either for minor children or perhaps even continuing education for yourself: What opportunities are available?
- Is there public transportation available if you need it?

Exercise 25
Industry Terminology
Locate a website that specializes in apparel-related terminology, and find definitions for the following terms:
- Cutter's must
- Style sheet
- Mood board
- White paper

In the final chapter you will have the opportunity to conduct several real-world case studies. Using everything you have mastered thus far, go to the GOODIES CD and refer back to reference aids on the **Goodies CD> Chapter 7 >URLs at a Glance** and **Chapter 8>CAD FOLDER SUPPLIERS.**

Your list of favorite websites

Name	Web Address	Area of Specialization	Additional Comments
1.			
2.			
3.			
4.			
5.			
6.			
7.			
8.			
9.			
10.			

Did you enjoy surfing the Web? It wasn't that difficult, was it? You went to India for cotton, Hong Kong for buttons, New York for forecasting, and Milan for inspiration from "your" favorite designer, or into the past for insight into the gown from the Renaissance . . . all without leaving your desk. Is it any wonder

that in this ever-increasing cost-conscious world the trend for sourcing will be done more and more online?

You have completed the exercises and you are expecting me to direct you to the Goodies CD for the answers, right? Well, by now you should have discovered that the Internet truly is organic and ever changing; therefore, the solutions found when the text was written may or may not be the best solutions for you today. The goal of the book was to teach *you* how to find answers and how to rank and evaluate them.

So, how did you do? Do you feel your responses were good, better than average, or the best available? Challenge yourself, try the exercises again in a week or even in a month and then compare results.

For a copy of the complete chapter exercises, go to **Goodies CD> Chapter 8> Exercises.**

Notes:

9. Case Studies

Introduction

Much of the time your work as a fashion professional will be to gather and assess data as it applies to the company for which you are designing. You will be expected to research and source information, services, and supplies for a number of projects. This means sifting through volumes of material that may or may not be applicable to your product or line. However, as you saw from the interviews with industry insiders in Chapter 6, your main job is to ask questions and gather information in order to glean relevant information to help you best determine how to save time and money, and to ultimately *best serve your client!*

While it may take time to get used to sorting and sifting through information, I suggest always keeping a journal handy to jot down your thoughts, ideas, inspiration, and finds. Obviously, the best way to do this is electronically. A PDA can be worth its weight in gold for the researcher because your information can be downloaded to your computer later for analyzing and refining. If you prefer to work online the copy-and-paste function of your basic word processor helps you accumulate vast amounts of information, stats, and facts to later integrate into your reports. I have chosen to begin with Cotton Inc. because of the online wealth of information that is so easy to find and apply.

The company has one of the more user-friendly sites for the fashion professional. So, let's begin this sample case study together by logging-on to the Internet and *http://www.cottoninc.com* for some hands-on exercises. It is important for you to become acquainted with this valuable resource.

Investigational Skills

The first exercise will help you put into practice several skills and concepts you discovered in earlier chapters. The later exercises will help you create reports and products that are thoroughly well researched and timely for your company and clientele by making the best use of your research, observational, and conversational skills.

Much of the exercise work you will be doing involves a bit of role-play, where you are challenged to wear many hats—those of a researcher, product developer, designer, or other creative professional.

Case Study #1: Cottoninc.com
Together let's do a quick hands-on search to find out more about Cotton Inc.

- Where should you begin your search?
- How would you determine who are Cotton Inc.'s competitors?

- Where would you find a company fact sheet?
- Where would you find press releases on the company?
- How would you locate the key company personnel?
- How would you determine what products or services a company offers?
- How would you find out if there were any job opportunities within the company?

Annotate your findings in a word processor and save this file as Cottoninc.rtf.

Next, let's take a look at several other key fiber companies and compare websites. Be sure to annotate and save these findings in a file entitled Fiber-comparison.rtf.

Hint: Go to Hoovers.com (http://www.hoovers.com/free/ind/dir.xhtml) to get their main industry directory. (See Figure 9-1.)

a. DuPont
b. Celanese
c. Milliken

Figure 9-1

Notes:

Observational Skills

Now that you are more familiar with the advantages of cotton, we can turn our attention to companies that use cotton in their product lines.

For role-playing purposes let's incorporate your visual skills for observing trends into a practical project. Begin by focusing your study on swimwear that has a high content of cotton. Next, locate three different companies that you know specialize in contemporary women's swimwear primarily made from cotton fiber–based fabrics.

Your job is to find three key vendors that fit this market description and thoroughly research them to determine which one you would like to be designing for.

You would probably agree that swimwear and jeans are the two most difficult items for an individual to be completely satisfied with in terms of fit. Therefore, taking time to acquire information from consumers on what works, what does not work, and why can be invaluable to the design process.

Feel free to begin with yourself if you happen to be in the age or size market for the product you will be designing for. Think about your own personal observations—pros and cons—for swimwear brands that you like. Ask yourself what works well and why. Determine what improvements you would make, and why. If you are not part of this demographic market, search out someone you know who is. Next, solicit that person for answers and insights on swimwear.

Let's assume you are the head designer for the brand you have chosen. Begin to look to the past few seasons for what was popular and why, along with determining the direction you feel swimwear will be headed for next year's spring–summer season.

Annotate your findings. Gather images to determine trends in:
• Colors
• Fabrics used
• Fiber blends
• Finishing used
• Care and storage issues for garments
• Garment details
• Garment finishings and trims
• Body silhouette

Conversational Skills—*The Informational Interview*

Visit your local malls and specialty stores and speak with the sales staff about the product lines that are made from cotton. Think of at least five different questions you would like to ask in the course of your time there that could help you improve or enhance a better collection for your client. An example may be *which style sells the most and why.*

Reality Check *Practical Application for Your Research*

You should gather a wide body of research from this simple assignment employing all the skills you have learned in the earlier chapters.

Based on your initial research and your field research, what are your conclusions? Now is the time to formulate your thoughts on how well you completed your research. Do you think you have all the facts that quantify your decisions? Are you ready to pitch your ideas to your supervisor on the direction you feel the new collection should take? If you feel you are ready, type up a memo with your findings and accompany it with an inspiration board with your ideas for the next collection.

Set aside your research for a few weeks and then go back and reevaluate your conclusions. Did you overlook anything? Did you make any assumptions that you don't have the facts or stats to quantify your conclusions? Are you brave enough to submit the results to an impartial source for evaluation of your findings? The hardest thing for fashion professionals may be to quantify what they seem to instinctively know from years of practice. However, designing is not about divining! It is about facts, stats, and informed "predictions" based on this information.

If you feel comfortable with your findings, you are ready to move on to some other case-study exercises!

Case Study #2: Art Deco–Inspired Line of Fabric Prints for the Petite Market

Advanced Fashion Application

You have been asked by your manager to design a line of better related petite sportswear separates for a private label. Your research will include information on types of prints to be used on the fabric for next fall. The theme is Art Deco–inspired prints. Where would you go first?

• Search for the following:
 • Information and images on the Art Deco period of art and architecture
 • Leading artists and examples of their work
 • Leading fashion designers of the period and examples from their collections
 • Leading textile artist from the period
 • Signature fashion elements that were indicative of the period such as:
 • Dominating silhouettes
 • Favorite color palettes
 • Fibers and fabric used
 • Important details
• Obtain the most current demographics and psychographics for petites.
• Determine what are the main concerns for the petite woman when purchasing.
• Next, locate three top designers or popular manufacturers who specialize in petite clothing.
• Compare and contrast the different lines, and list the different retail venues in which the lines are sold.
• Which is the most popular with the woman in her 30s, 40s, and 50s?
• Define each company signature look. Begin to clearly annotate the following facts:
 • Price point (e.g., popular, moderate, better, or designer).
 • Consumer taste level (e.g., conservative, updated, or advanced).
 • Design a new collection for a private label; draw at least 15 related separates as technical drawings to be placed on presentation boards. (Other names for technical drawings are mini-bodies or croquis.)
 • Select a color palette and make a color card presentation board.
 • Determine how color, scale of the print, and other design considerations should be evaluated for your market segment.
• If you are trained on the computer you can begin to render digitally the following fabrics to be an updated reflection of Art Deco–inspired fabrics. If you are not trained on the computer you can do a mock-up of presentation boards with swatches and swipes to depict your findings. For the reader who would like to learn more about how to digitally render fabrics you can go to my

website at *http://www.computersandfashion.com* or to the Prentice Hall website to learn more about my other books: *Rendering Fashion, Fabric and Prints with Adobe Photoshop* (2004), or the newest version using Adobe Illustrator available fall 2005 by M. Kathleen Colussy and Steve Greenberg.

In every era you will always find the following list of fabrics and prints. What defines a given era is how the fabric or print is interpreted. For example, during the Empire period, stripes, also known as ticking, were wide. In the Rococo period, floral prints were large and often accompanied by thin ribbon stripes. Successful print designs are ones that can be mixed and matched to coordinate in a variety of different formats.
- Solid fabric
- Stripe
- Check
- Plaid
- Floral
- Geometric . remember, all of these patterns must be able to mix and match! You are designing a line of related separates, so make your selections carefully.

Putting It into Practice
- Make a digital moodboard with your findings.
- Annotate the results of your query in bullet style with Images in a MicroSoft PowerPoint presentation.

Great Recommendation URLs
- http://moma.org/collection/depts/paint_sculpt/blowups/paint_sculpt_020.html
- http://www.sfmoma.org/collections/recent_acquisitions/ma_coll_duchamp.html
- http://www.philamuseum.org/collections/modern_contemporary/1950-134-59.shtml
- http://www.artcyclopedia.com

Next go to GOODIES CD> Chapter 7> to search the URL databases.

List the additional sites you found here:

1.

2.

3.

4.

5.

Case Study #3: Levi's and Cotton Trends for Men
Advanced Fashion Application

Using these two great company sites, determine what the trend will be for men's jeans for next year for fall and winter.

http://www.levistrauss.com/ and *http://www.cottoninc.com*

Hint : Go to GOODIES CD> PDF Files> search the Cottoninc files for preliminary information.

Next Go to GOODIES CD> Chapter 7> to search the URL databases for forecasting information, as well as marketing statistics sites on demographics and psychographics.

Highly Recommended URLs:
http://www.levistrauss.com/news/
http://www.us.levi.com/fal04a/levi/main.jsp

List the additional sites you found here:
1.

2.

3.

4.

5.

Case Study #4: Denim Trend Analysis
Advanced Fashion Application
Compare and contrast last year and this year for the following:
• What brands of denim are the most popular?
• What styles and brands are out of fashion?

- What kinds of jean shapes or silhouettes are women wearing? Are men wearing?
- Are there any new trends in colors, washes, or treatments from one year ago? From two years ago?
- What are the hot colors, what are the safe colors, and what colors are out?
- Are customized jeans important? If so, what kinds of details or sizing are you noticing?
- Is vintage important?
- What are the main jean labels for the following price points:
 - Popular (budget)
 - Moderate
 - Better
 - Designer
- What other items are you seeing made in denim?
- What type of weave are you noticing in denims that may be different from several years ago?
- What were the leading websites you located on denim that provided insight into the above questions? Will these sites likely be there one year from now? Five years from now?
- Who were the leading denim companies in 1964, 1974, 1984, and 1994? Which are still around today?

Case Study #5: Hispanic Influence on Fashion
Advanced Fashion Application
Let's assume the company you are working for is considering developing a new line of clothing, and they have asked you to conduct the research. This kind of research is known as a white paper. Typically, a white paper explains the results, conclusions, or construction resulting from some organized committee or research collaboration or design and development effort.

For this case study you will need to write an exercise on the influence of Hispanics on fashion in the United States. You can cite arbiters in different arts or other areas who are Hispanic influences on fashion.

Hint: Go to the GOODIES CD> PDF Files> to search the Cottoninc files for preliminary information.

Next, go to GOODIES CD> Chapter 7> to search the URL databases for forecasting information, as well as marketing statistics sites on demographics and psychographics.

Case Study #6: The Buying Power of Children
Advanced Fashion Application
You are to design a collection for children's wear for next summer. Go online and determine the trends in:
1. Silhouettes
2. Fabrics
3. Colors
4. Patterns
5. Details
6. Trims

From your results make the following:
a. Memo with your statistical research
b. Moodboard or inspiration board for your line
c. Technical drawings of your collections
d. Swipes for numbers 1–5 above

Hint: Go to GOODIES CD> PDF Files> to search the Cotton Inc. files for preliminary information.

Next, go to GOODIES CD> Chapter 7> to search the URL databases for forecasting information, as well as marketing statistics sites on demographics and psychographics.

Case Study #7: Changing Ideals of Beauty—Body Silhouette
Advanced Fashion Application
Determine the ideal body proportions for petite women for the following years:
1. 1950
2. 1960
3. 1980
4. 1990
5. 2005

Locate information about the standard sizing measurement for women from 1950 to 2005. What has changed? Upon closer examination determine the average dress size in 1954, 1964, and so on. What are the standard sizes today? Were distinctions made for petites, misses, and plus sizes during any of these years? Who oversees the standardizing process for the United States? For the United Kingdom?

Hint: Go to http://museum.nist.gov/exhibits/apparel.recent.htm.

Next, go to GOODIES CD> Chapter 7> to search the URL databases for forecasting information, as well as marketing statistics sites on demographics and psychographics.

Case Study #8: Swimwear Trend Analysis
Advanced Fashion Application
Part 1: Using Hoover's, compare and contrast four major contemporary women's swimwear labels or brands, by target market and price point.

Part 2: Locate five trends for summer contemporary women's swimwear two years from now. Cite the information.

Part 3: Compare and contrast styles of swimwear one and two years ago. Type your findings in bullet style, noting the same: what's new and where you found your information and images. Next, determine what will carry over two years from now.

Case Study #9: Historical Revival Trend Analysis
Advanced Fashion Application
The year is 1964—can you locate the following:
• Information on the favorite pastimes.
• Information on the culture such as the most popular movies, music, art, and theater.
• Information on the leading art movement.
• Information on the hottest fashion trends including who were the leading designers in the United States and in Europe.
 • What were the important color stories?
 • What were the latest prints or patterns in clothing?
 • What were the important clothing details (e.g., types of collars, sleeves, hem length, etc.).
 • What were the most significant fibers and fabrics used?
 • What types of shoes and accessories were in fashion?
• Information on the major economic facts for that year.
 • What was the cost of a four-bedroom house?
 • What was the cost of a new car?
 • What was the cost of a dress?
 • What was the average life expectancy?

Now, take what you have gleaned and design a contemporary line of women's clothes based on this era!

Also, check the Goodies CD for this complete chapter: **Goodies CD> Chapter Nine Case Study Exercises**.

Go to Goodies CD> PDF Folder for >COTTONINC for:
1. 0604 Textiles Consumer Children Pref Stats
2. 1997 Plus Article
3. 1201 Multi Cultural Consumer
4. 2002 An Expanding Market-Plus
5. Population Changes Charted
6. 2004 Cotton Fiber Chart
Space is provided below for you to jot down some of your favorite sites. Annotate them, bookmark them, and by all means, share them—go online and visit my site and drop me an email with what you have found.

I can be reached at *http://www.ComputersandFashion.com*. I appreciate your feedback, and will be continuously updating the recommendations received from my readers on my website. It will not be long until you are well on your way to becoming a *fashion sleuth!*

With thanks and best wishes,

Kathleen
AKA: Inspector Trousseau—Your Official Fashion Sleuth

Notes: